The Business Model
A Handbook for New Models Who Have a Head on Their Shoulders

Joe Teeples

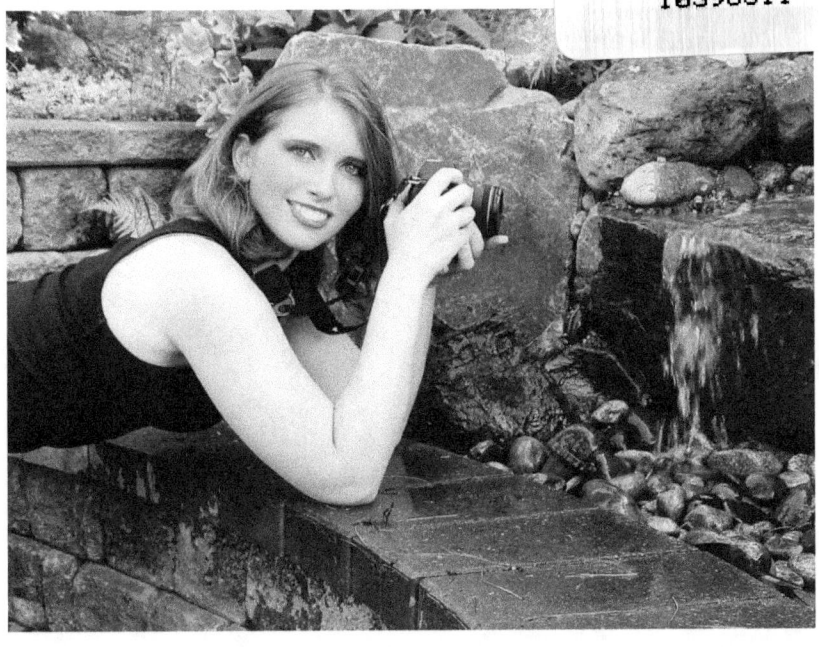

This book is copyright Joe Teeples

Table of Contents

- Introduction 4
- Is it worth it? 6
- Elements of success 11
- Getting started 13
- Modeling Agency 16
- Freelance Model 19
- Legal Stuff 21
- Marketing Yourself 24
- Personal Safety 30
- Keep in touch with good people 33
- The Photographers 35
- The Make Up Artists 40
- Hair Stylists 42
- Locations 44
- Setting up the shoot 47
- Basic Wardrobe/Props and Model Kit 49
- Basic Poses you should master 57
 - Sample Business Plan – 69
 - Sample Forms - Model Release, Location Release, Waivers
- Checklist for Success 111

Introduction

Your friends and family all say you could be a model. They tell you that you have the looks and the temperament to be successful at it. Looking at magazine ads and television you think, 'sure, I can do that'. If only there was some way that you could get help getting started, to answer those questions that come up in the prospective models mind.

Thoughts that plague new models include:

- They say I should be a model, really?
- Do I have what it takes?
- How do I get started?
- Where do I find a photographer?
- Do I need a huge wardrobe?
- Can people really make a living at this?
- What are the pitfalls of modeling?
- Should I do it as a hobby or as a business?
- What if I fail?

The intent of this book is to answer those questions. The authors feel that models often get caught up in the chase of finding someone to take their picture, thinking that things will magically happen and that they will be discovered.

Modeling does take a lot of work. But it can also be a lot of fun. The authors would love to hold your hand and guide you through the steps to become a successful model and have developed this guidebook to accomplish that end.

As you go through this manual you will find a lot of references to the Pacific Northwest. That is where I am based, so it makes sense to use those references that I am most familiar with. If you are in Texas or on the East Coast, there are just as many opportunities in those regions. Don't be shy about making notes on the book pages here! Mark it up and add to it. Make it your own personal work book.

Is it worth it?

If it's your passion, of course it's worth it. Some models enjoy the work and get a handsome paycheck having their pictures taken. Others model because the craft is in their soul, crying to be released as a form of self-expression.

Whatever the reason, it's worth it. You're probably not going to get rich. Few make a full time living at it. Most are happy to be able to pay some bills and meet some exciting people. That's a lot better than hanging out on Facebook and twitter sending your friends photos of your cats……..

Models should realize that the income generated from this business… and it is a business…. Increases along with their skill and what they bring to the shoot. New models start out doing quite a bit of free modeling in order to build up their portfolio. Once that portfolio is established they can charge for their services.

Don't forget that attending a free shoot (Often known as a Trade For or TF shoot) is a great way to keep your name in circulation. You also get to meet photographers who you may not normally be exposed to. Quite often this leads to a paid gig down the road.

As a freelance model, the amount of income you earn is up to you. Some sites such as Model Mayhem are a good place to start your journey by looking at how much those models are charging. Models post their fees which can range from $50 to $150 per hour. It's up to you. If you are doing an outdoor cute photo you can negotiate lower rates. Once the photographer asks about 'implied nude', nude or topless images, raise your rate. It's that simple.

There are several different types of models. The New York style high end **Fashion Model** is the top of the business. There are also plenty of models who make a nice little income as a **Glamour Model**. Most models produce an income as a **Commercial Model.**

The Fashion Model is also known as the editorial fashion model and they mostly work in New York City. Unless its winter, when you can bump into them in Miami. In order to become one of these supermodels, the model should fit into the following category:
- Live in New York
- Five feet nine inches up to six feet tall
- 15-19 years old
- Really thin, perhaps 110 pounds
- Breasts less than 34C, no tattoos, stretch marks, tan
- Better than pretty… Beautiful. Drop dead gorgeous…
- Willingness to travel to strange locations without a family support system
- Commitment to modeling
- Thick skin, you'll get lots of rejections

The Glamour model is often confused with the fashion model. Remember that these are the models that often grace the auto or boat show with their pretty faces and athletic bodies. This promotional work for large corporations brings in the buyers for the conventions. The age range for these promotional models can range from 18-30 and most of the models get their jobs through self-promotion. Another aspect of this type of model is nude or 'cheesecake' modeling jobs, calendars or highlighting product through the use of their pretty bodies.

Commercial models get published in catalogs, work in fashion shows and print ads. This is the back bone of the modeling industry. Very few models can make a living doing commercial modeling outside the major cities. In this arena models can be heavier, older and need not be as beautiful as the fashion model. They are also cast in roles such as 'active housewife' or 'upcoming career woman' to portray some of these roles. Attributes of a successful commercial model is an outgoing personality and a certain amount of acting skill. Confidence and the ability to present themselves, along with availability for shoots make a winning combination.

Maximize your income. You need to get that revenue stream going, and that means you have to be in front of the camera. Once you have determined what your rates are, keep a list of those photographers and agencies that match those rates. The rates can range from nothing for a TF shoot (no cash, but lots of exposure to photographers) to several hundred dollars an hour. You'll probably start with a fee of $50 per hour for a two hour minimum. As you get better and are willing to be more edgy, you can raise the rate.

Don't forget that you can augment your modeling income by selling your images online or at trade shows. Get the best quality images and offer them to the public. They could be sexy pinup shots, funny and amusing images or even Cosplay or Anime images. Models spend a lot of time developing a character, creating a costume and then attend the conventions to be seen. The public will part with $5 or $10 for a signed autograph of a lovely model!

Models can attend the conventions and get a vendor booth to sell their images. In Seattle there are Fairy conventions, science fiction conventions, horror conventions and creative people often sell their artwork there. Check out some of the online places that images can be sold:

 www.smugmug.com
 www.etsy.com
 www.modelmayhem.com
 www.bigcartel.com
 www.squarespace.com
 www.storeEnvy.com

Elements of success

The following elements contribute to the individual success of a model. First off, location plays a big part in how often you can shoot and how much money you will be able to charge for your services. There has to be a supply of photographers in the area to establish a market. The more photographers there are, the more demand there will be for your services. For example, there are a lot of camera bugs in the Seattle area who are willing to pay for a models time. Not so many in Wenatchee… Still, if you live in Wenatchee and can drive the two or three hours to a large city for a shoot it makes the drive worthwhile.

Another consideration is your body type and height. The look is what you are selling and it has to fit the project. This will have an impact on your sales. Take care of your body. Stay healthy and work out from time to time. Those minor skin blemishes and 'awkward tones' can often be countered with the proper use of makeup and wardrobe. It's your body, you've seen it and you know where your strong points are and your weak points are. Do your best to accentuate the best parts of your body. Don't hesitate to tell the photographer that 'This is my best side'. If you have a tattoo on your right arm that you'd rather not be part of your portfolio you should let the photographer know so that he can concentrate on taking images from your left side.

The models attitude is a huge factor in how often a photographer uses her. Even if she is a little thin or a little too heavy for a shoot, if the photographer enjoys working with her because she has a positive, 'can do' attitude and is willing to be directed and try new poses, she will get call backs. And more call backs means more images for your portfolio and more money in your bank account!

In order to maximize your success you want to make an investment in yourself. You want to get the best return from your efforts that you can. Concentrate on getting the best images, the best photographer, the best reputation and the best cash flow. This requires an investment in your time, resources and yes, in your money.

Modeling is a job and you should bring to any job the commitment to be there on time and to take the job seriously. This requires self- discipline. Nothing infuriates photographers more than last minute cancellations. Especially when the model cancels and then posts on Facebook what a great time she is having at the park with her new friend!

Master the self confidence that you are a professional model, that you have the skills and know how to make it in this line of work. The ability to get along with others and pitch in to make each shoot a success can be the difference between future paid gigs or no work coming your way. Your personal attitude will make a big difference!

Getting started

Let's walk through a typical shoot for a beginning model. We'll assume that you responded to an online ad for models. This is a gathering of models for what is known as a photo shoot. The ad looked something like this:

"Seeking models for a TF shoot for a possible publication. Models should bring their own wardrobe. PM me for details."

You checked with your friends and the organizer is well known. He's a photographer who has done these before and your friends in the modelling community like him. They explain to you that 'TF' stands for 'Trade For'. That means that no one gets paid. Everyone contributes their time and skill to the shoot. In exchange for agreeing to model, the photographer will provide images that models can use to build up their portfolio. 'PM' means 'Private Message'.

Send the coordinator a personal note explaining that you are interested in shooting, the kind of experience you have and what sort of outfits you'd like to be photographed in.

When the photographer responded he said he'd love to shoot you. He suggested that you bring a few changes of wardrobe and meet him and the other models and make-up artists at the Preston Mill State Park at Ten O' Clock on the day of the shoot.

When you arrive at the shoot location you leave the three outfits (The jeans and western shirt, the prom gown and the basic black dress) in the car and introduce yourself to the photographer, make-up artist and other models. Look around the site and find out where the bathrooms are, drinking fountains and if there is a place to change wardrobe. Exchange business cards so you can contact each other after the shoot.

The photographer should explain the concept of the event to you and the other models. Then he should pass out a model release form for you to sign. The model release form provides protection for both the model and the photographer. Sign the agreement and be sure that the photographer has your contact information on the form. You are pretty shrewd, so before you hand it to the organizer you snap a photo of the signed agreement with your phone! You have a copy of the contract. That takes care of the paperwork. See the section in this book on model releases and license agreements for a more detailed explanation. For right now, just sign the model release and keep a copy.

Get ready for the shoot and put your best show on! If there is a makeup artist or hairstylist at the shoot, get there quickly to get done up. Don't wait until there is a line. You came there to model, not to chit chat with the other models.

Some TF shoots have a clap board type of arrangement for the model to write her name on to create a 'head shot' of the model. This could be a chalk board or a white -board that you hold under your chin as someone takes a photo. Put the make-up artist and hair stylists name on the board to give them credit, too. This way all the photographers can identify you and get their images to you. It may sound strange, but once you are made up (especially for a themed shoot such as vampires or zombies) the photographers may not recognize you! Once you are made up, get into the wardrobe and let the photographer know you are ready.

Now you're ready to shoot. Follow the photographers lead and if you have a best side, tell him. If you are sensitive about a certain body area, tell him. I went through an entire shoot with a model who told me at the very end, as the light was fading "I'm really sensitive about my stomach…" During the shoot I could have positioned props in front of her slight tummy, or had her stand behind branches to conceal her concern…

At the end of the shoot, gather all your gear and get ready to leave. Don't forget to say goodbye to everyone, even if you didn't shoot with them. Tell them that you'd love to shoot with them next time! It goes a long way towards creating future business.

Modeling Agency

Many models often dream of signing up with a modeling agency that will promote them and get contracts for them. In an ideal world the model would be contacted by an aggressive agency who explains that they have two shoots lined up for today. One is an automobile spread for General Motors and the other is a clothing line for swimsuits. Each will be on location near the same beach. All the model needs do is show up in the morning and do some simple poses, then head to the second location in the afternoon and repeat the process wearing several swimsuits. The check will be in the mail. That would be perfect, wouldn't it? (Here's a thought… Photographers dream about the same agency doing the same for them!!!)

Agencies represent models to companies. The companies often have an idea of the type of model that they need for a certain campaign. They may want a strong, athletic model to sell automobiles or a wholesome, down on the farm looking model for an organic food store. The models mission is to let the agency know that he or she can provide the look that the client is looking for. This is where the comp card comes in!

The comp card is your ticket to modeling agencies. It is a half sheet of paper with about five images on it that represent your various looks. It is two sided and the back has your measurements and a space where the agency can put their sticker. This is what they send to the company along with a note such as 'Hey, I think this model would be great for that floral magazine ad…."

Do not put your contact information on the comp card. You need a business card with that information to go along with it to the agency. The agency does not want the client contacting you directly. So let them do their job and promote you, make it easy for them to do so and they will send more work your way.

Agencies want models that are ready to work, have some experience and the marketing materials that they need to use to sell that model. Don't be discouraged if you have a large portfolio and a wonderful comp card that the agency just doesn't want to use. These are tools for you to use in order to get your foot in the door. If the Agency only uses one of your portfolio images and wants to reshoot the others, consider that success! They have a certain need, look or feel and they obviously feel that you would be an asset to their team!

If you can get into one of the agencies, that's great. They do most of the marketing for you and set up assignments. The models that get the most work are requested by photographers for a variety of reasons. They are punctual, show up on time prepared to shoot and don't waste the teams time. This is a business and the scenery, setting and sunlight often changes quickly. Successful models know the basic poses and take direction well. Once the shooting is under way is not the time for the model to have second thoughts or tell the photographer 'I don't feel comfortable with that pose…' Negotiations have been done and signed with the model release which is the contract.

The Agency expects the model to show up ready to work with the photographer for a set period of time and close out the shoot. For this reason people often see the model show up on set, do a quick make up check, hit the poses and leave. This happens all in the matter of a few hours. What people do not see is the number of hours that the Agency and model spent negotiation the images, applying make-up and getting to the location.

In order to convince a top line Agency to take on a new model the model has to apply to the Agency. Then an interview will be set up where the model will explain how she fits into the Agency and what she brings to the Agency. This is when the Agency will want to see some of the models work in the form of a portfolio. (Remember that TF shoot? The one where models gave their time in exchange for images for their portfolio? It starts to make sense, now, doesn't it?)

Freelance

Many successful models work on their own as freelance artists. This allows them to control the type of assignment they get involved in. It also allows them to choose their working hours. Some models only model on the weekends which will allow them to have a 'regular' job that pays the bills.

Freelance models are truly in charge of their own fate. They also have to take care of all the details and hustle to get photographic assignments.

Working with other models…
We take the good with the bad. There are really tremendous models who are highly photogenic and experienced enough to know what the photographer wants. Then there are other models that lack the experience most photographers look for. These models are usually new and building their resume's and portfolios. Hey, we all have to start somewhere, don't we? Somewhere along the line you are going to work with other models. It can be fun, interesting, educational and frustrating all at the same time. Learn from the experience!

Model Mayhem (www.modelmayhem.com) is a good site for models who are over 20 and prepared to market themselves through social media. Basic entry is free and models can purchase additional space and services to enhance their salability.

Fetlife (www.fetlife.com) is an adult themed website that is used primarily to discover new talent that is interested in nude and fetish type photography. Those models who are not shy and are willing to do nude or implied nude photography can make some lucrative connections on this site.

ISO Connection (www.isoconnection.com) is a site that is similar to Model Mayhem where prospective models can provide an electronic portfolio.

Legal Forms

There are two legal forms that models should be familiar with. The first is the model release that gives the photographer the right to photograph the model. The second is the Licensing Agreement that allows the model to reproduce or marker the images that the photographer has captured.

Model Releases

Most TF shoots are designed so that the model gets a few images for their portfolio. They can't sell them unless the photographer gives them the rights to do so.

When the photographer snaps the shutter release an image is created. The photographer owns that image. He or she has just created it. Without a model release, the model has a difficult time controlling their images after the shoot. They may not even get copies of the photographs! Without a signed release, the model has no legal recourse. Most release forms also have the contact information for the model that the photographer will use to deliver the images.

In exchange for allowing the image to be captured, the model can ask for and receive certain things. This is specified in the model release form. For example, the model may demand that no images of nudity or even implied nudity will be taken. The model may agree to pose in exchange for five or six images in electronic form or on a CD. Or they may agree to be included in a magazine or book and receive copies of that publication. The agreement may state how much money and for how many hours the model will pose. There is a copy of the model release in the back of this book.

Licensing Agreements

Many models augment their income by selling their images. This is routinely done for Cosplay, Comic Conventions, Crypticon Events or other gatherings where people are inspired and awed by the models costume and character development.

Always remember that the photographer creates the image. The photographer owns the image. They do not have to put a watermark on it or register it in order to obtain this ownership. In order to reproduce that image the model must obtain permission to do so. This is called a license. A model may purchase, barter or trade for this permission. A non-profit initiative has been established known as PLUS (the Picture Licensing universal system) by the American Society of Media Photographers. They describe a license as 'a legal agreement granting permission to exercise a specific right to a work'.

A license can be obtained by commissioning a photographer to shoot the images. The model pays the photographer for the images and owns the images as product. This is known as Assignment Photography. More often the model will use a 'Stock Photography' system. In this method the photographer will license the images to the model in exchange for payment or services.

There are three categories of licenses.

Commercial licenses are used to sell or promote something, such as billboards, product package or web sites.

Editorial licenses are used for journalistic and educational purposes such as magazines, newspapers and text books.

Retail licenses are used for personal use such as fine art prints, greeting cards, posters and models selling their images at conventions.

Some photographers ask that the images or prints be purchased from them. Some photographers will not let the model sell the images at all. It is critical to get permission to do so if you intend to sell your images. Be sure to negotiate with the photographer BEFORE you pose to make sure that you have the rights to reproduce the image.

The photographer will develop a license that grants the model an agreed scope of usage and ensures that the model understands what they can and cannot do with the image. This protects the photographs from unlicensed use.

The license should include the type of media that can be reproduces as well as the distribution format. For example, it may specify a magazine advertisement for printed or electronic download. It may also specify what type of placement can be uses for a magazine. Other factors are the quantity of reproductions that may be distributed (10,000 copies), and the duration of the license (up to six months from date of the contract). The license should include a start date and an end date along with any media or region constraints that the photographer wants to impose.

Marketing yourself

"Please don't depend on other people to provide work for you."
 Lisa Kudrow

Modeling is the peak of a competitive world. There are a lot of very good attractive and professional models waiting for their big chance. It is up to you to market yourself. You have to actively seek photo shoots and modeling jobs. Always remember that this is a business and strive to remain competitive. Develop a strong resume and an excellent portfolio of the best images that you've provided to photographers. Think of a business model that moves from advertising to marketing to sales. Most companies have different departments for each of these. In your case, you'll be doing it all!

Many models spend a good deal of time 'getting their image out there'. They post on social media sites, doing shows and working with photographers. These types of events are good for creating a demand for your services. In the business world, this is known as advertising. You see this all the time when you consider magazine or newspaper advertising. A big billboard that says 'McDonalds Restaurant' is a form of advertisement.

Advertising leads to marketing. Now that they know about you, have seen your image and realize that you do modelling, you have to market yourself. McDonalds does this by using coupons or a two for one sale in an attempt to get you into their restaurant. To market yourself you have to do more than just throw your image out on Facebook.

Begin to lure them in with comments that accompany your images. "I just shot with Joe out in the Wenatchee Forest. We had a lot of fun and as you know, I LOVE shooting outdoors! More images soon!" Now you have other photographers looking at your image and hearing that you are a fun person to work with and that you do outdoor poses. More enticing than just an image of you in the woods, isn't it?

Call backs! - It is much easier to get someone who has worked well with you to hire you again than try to develop a new client! That is where TF shoots turn in to paid shoots. Get out there and work with photographers at the TF shoots. Get to know them. Speak frankly about the fact that you love doing TF shoots, but you really must spend more time doing paid gigs. Dropping a line like "I love doing Trade for shoots like this, but I just can't do too many of them. Most of my shoots are paid. And I'd really like to work with you again."

If the photographer has asked you to do an implied nude or nude shot during a TF shoot, that opens the door for you. You know that he wants to shoot you; there is a demand for it. Now is the time to negotiate. Use a phrase like "I'd really love to do that pose for you, but I can't do that at a TF shoot. It just wouldn't be fair to the other photographers who have paid for that type of image, don't you think?" That goes a long way to securing a paid gig.

Think about a business name. It's ok to use a 'stage name' in order to keep your personal life separate from your modeling life. The name should be short and memorable. It should also be easy to spell. Too often models will select an exotic sounding name that clients can't spell or look up on the internet. Names such as 'Latifa-Extraordinaire' sound exotic until you compare it with the completion. Try typing that name into a search engine. Don't forget the hyphen!!!

Another consideration for names is something that lets people know what type of modeling work you seek. 'Bikini Barbie' is a catchy name for swimsuit models. 'Bondage Becky' wonders why she keeps getting calls from photographers looking for fetish work when she's trying to build her glamour portfolio.

Develop a plan to promote yourself. Make a business plan. (I've provided a sample in the back of this book). The business end of this is going to require an investment. As a minimum, you should have:
- Business cards
- Head Shots and Comp Cards
- Portfolio
- A bag of tricks
- Modeling skills
- Self-presentation skills
- Communications
- Transportation

Business cards are nice little bundles of information that allow you to keep in touch with your business contacts. They should include your name, address, phone number and email address. You can also put a web site address there if you have a professional web site. Include your Facebook business page. If you belong to a social networking site such as 'model mayhem' or 'iso connections' you may add that information onto your card so that the prospective client can review your posted portfolio.

Use 8x10 glossy head shots to sell your services to a client. These prints can be expensive, but if you are doing a 'TF' shoot, the photographer can often provide quality prints for your portfolio. You should also have a portfolio of 8x10 images that you can bring with you to prospective clients or agencies. Most photographers have a quality photo printer and will be happy to do it for you. If you are going to give your prospective client an 8x10 you should have some nice, high definition, quality glossy images. Put your name and contact information on the <u>back</u> of each photo.

Composite Photo Cards should include a face shot, body shot and a side profile shot. They are often called a Comp Card or a Zed Card and are your main selling tool. Instead of giving the client an 8x10 photograph, this 5 ½ inch wide by 8 ½ inch tall sheet of durable paper provides much more information. They allow the model to provide a small collection of images on heavy paper to prospective clients. Most of these are professionally done, but are pretty inexpensive considering that it is a very powerful sales tool. You want to put a high quality head shot image that grabs the attention of the client from across the room. Other images can show your versatility, experience and the

kind of work that you are looking for. Do not put your contact information on the comp card. Leave room at the bottom of the back for the Agency to put their sticker on. This allows the agency to promote you as their product. If you meet a client who asks for a comp card, provide one AND your business card.

Some sources for composite card printing are:
- Compcard.com
- Otlgraphics.com
- Modelcards.com

Develop a portfolio that you can bring with you when meeting prospective photographers or agents. You can purchase an 8x10 portfolio from stores such as Hobby Lobby for under $10. Put the best shots that you have from your shoots inside. Use a variety of shots ranging from a head shot to a full length standing, sitting and lying pose. Let them know what you are capable of doing for them.

Each model is unique and will develop their 'bag of tricks'. On some assignments wardrobe and make up will be provided. On others the model is left to her own devices. You should have a basic set of makeup, wardrobe and shoes that make it easy for the photographer to cast an image and catch your post. Get a good, strong travel bag to keep this equipment in.

Always… Always bring comp cards and business cards to every single shoot or photographic event that you attend! Make it easy for makeup artists and photographers to contact you when they need a model.

Your modeling skills are your ticket to success. Develop them. Study books with poses, hand gestures and the like. When you see an image that takes your breath away, try to emulate the posture. Is the chin lifted ever so slightly? Compared to where her face is looking, what are her eyes focused on? Photographers enjoy working with experienced models who they can give a scene to and just tell the model 'now, work it for me..." and the model goes through several poses, pausing at each one so that the photographer can capture the image, then move to the next pose.

Self-presentation should not be confused with modeling skills. The model should develop a fashion sense for a wardrobe and make up that presents her in the most favorable light. Such topics as posture and hair styling are important.

If the photographer can't reach you, they will go to the next model on their list. Make it easy for them to contact you. Too many models simply rely on Facebook as their sole method of contact. Think about an email address, a phone number, even a postal address so that people can contact you. A web site is a great way to show off your abilities. You can add a blog, images, even 'behind the scenes' video along with a way to reach you.

Seattle is a great city. And they have a great mass transit system. However, when the model is carrying her 'bag of tricks' and her make up to a shoot it can be a hindrance moving along the bus route. And if the shoot is out of town, the model must have a means of getting there. So think about your transportation needs.

Personal Safety

Make no mistake about this topic. Your personal safety is truly in your own hands. Answering an ad to model can be nerve wracking enough. Add to that the knowledge that there are certain types of people who prey on young and innocent models and you have a recipe for disaster. It's important to be able to spot an unsafe or bad situation. It is equally important to know how to get out of it.

Models often check out photographers before they agree to a shoot. Check out the Facebook page and any website that they have. Ask to see some of their work and ask for references before you meet.

Get to know other models through TF shoots or working at pageants. Keep in touch with them. Use the knowledge of the respectable and responsible models to make a decision on which photographers are trustworthy and professional and which ones are creeps. Models share this kind of information.

The first time you meet a photographer take a few moments to check him out. Ask to see his identification and credentials. As a minimum ask to see a business card and driver's license. Ask about the model release form. If this character doesn't want to show you any of those items the warning bells should be going off in your head!

Don't go alone. Bring a friend. There is nothing wrong with bringing along an escort to the photo shoot. Be sure that the escort understand what you are going to do and does not interfere with the photographer.

Always let someone know where you are going and when you should be done. Take a snapshot of the photographer and you and send it to a close friend. You can do this in a bubbly and flirtatious manner. 'Do you mind if I take a photo of my new photographer and me with my cell phone? Thank you SO much!'

If you get an awkward feeling about a shoot have someone call you about 15 minutes after the shoot is scheduled to begin. If the meet up isn't going as you planned, answer your phone and tell the photographer that a family emergency has come up that you have to take care of.

Hey, I'm only 17!

Glad you brought that up! Quite often the comp card shows a much more mature and older model even though the model is less than 18 years old. This can confuse the photographer who may forget that he is working with a minor. I've even had a model ask to do a TF shoot saying she wanted to work on her portfolio with some swim suit shots and implied nudes. I checked her Facebook page, no mention about age, but some nice poses. Then she mentioned that she'd like to get a few topless shots for her personal portfolio. The next email I got was from her mom, explaining that the model was only 15 years old!

Those under the age of 18 will have to have your model release signed by a parent or guardian. That person should also be with you at the shoot. That releases the images for publication and mom and daughter should realize that. The photographer gets to use the images and the model gets some photographs for their portfolio.

Mothers often let their young daughters get into modeling, suggesting it or even pushing them into the career. Mothers may be present during the shoot but should not interfere with the photographer. Keep an eye on the young model, mom, but don't interfere. I always like it when a mother is there (it helps to control the model) but stays away from the scene by about ten or fifteen feet. Close enough to make sure her daughter is safe, far enough away that she is not influencing the scene.

Keep in touch with Good People!

Your list of contacts will be your most important asset, believe it or not. As you begin to network with other models and photographers it is important to keep them 'in the loop' about what you are doing.

It is not that difficult to keep up with people. You can use a computer program such as Outlook, or even just a simple 3x5 set of cards with the important information on them. In the old days, a Rolodex filled with addresses and contact information was the most powerful tool in a models arsenal! You'll want to have the following information:

- Name
- Occupation (Photographer) (Model) (Make Up Artist)
- Physical Address
- Phone Number
- Email
- Website
- How you met
- Works well with
- Birthday

Don't forget to send birthday cards to those who have hired you in the past. It sounds a bit cheesy, I know… But building and maintaining a personal relationship will result in more paid gigs!

You want to keep in touch with those photographers who you work well with, especially those who have paid in the past. Put a star by those names and nurse the photographers who have contributed to your livelihood. Stroke their ego and keep in touch with them. There is nothing wrong with sending them a note every few months letting them know that you are available and ready to shoot.

Remember that these photographers are following you on social media. (Or they should be, if you're playing your cards right.) So when they see that you shot last week with Tom the Photographer, then the next day you were out at the waterfalls with Dawn the Portrait Specialist…. Well…. They may get the image that you are booked up! And not call. So, send them a note and tell them how much you miss working with them. Be sure to ask the photographer when you are going to shoot with him in the future.

The Photographers

It is the role of the photographer to create the best image of you that he or she can. Using the techniques of positioning and lighting as well as other unique gifts that they bring to the table, the results can be absolutely stunning.

But they can't do it all by themselves. They rely on the model to present their best look and work with them. They also rely on the make-up artist to bring out the coloring and texture that the image calls for. Often the photographer will provide the make-up artist, sometimes the make-up and hair styling is provided by the model.

What to expect from a photographer

Solid references are important. If you've never worked with a particular photographer, ask your network of models about him or her. Find out if the photographer provided images to you in a timely basis. It's a good idea to ask for printed images for your portfolio. The other models will be able to tell you that the photographer paid on time, delivered quality images and met the technical requirements called for. You can also find out if the photographer is connected with other photographers who may be interested in working with you. Most importantly… ask your fellow models if they would shoot with that photographer again. If the answer is no….

The model release should have the photographers contact information (phone, address, email) as well as the models. Always pick up a business card from the photographer. After the shoot the real work begins in digital photography as they use different programs to enhance and clean up the image.

You should hear from the photographer within a week of the shoot. Just a short note saying that they enjoyed working with you or when you can expect to see the images. If the release states how many images the model will receive for their portfolio, make sure that you get them by the specified date. If you don't receive them, contact the photographer and jog their memory.

What the photographer expects from you

Punctuality is important. The photographer has taken the time to set up the equipment and the models should be doing their best to get in front of the lens. If for some reason you can't make the shoot let the photographer know. Don't leave them standing in a field or studio trying to guess if you are showing up. If you are running late, let them know that, too. Most photographers will wait about fifteen minutes for a model. Don't miss your chance! Call them!

If the shoot is set for three or four hours and the model spends half that time chatting with the other models or changing wardrobe or makeup the photographer is losing valuable time that could be spent with other models. When you hear a photographer ask the question "Are you ready to shoot?" It means that they want to get some images captures while the lighting or setting is optimal.

Take care of your body. It's your asset! Clean hair and skin make for a very desirable image. If you are on a shoot for several hours, use your modeling kit to check yourself out and, if necessary, reapply makeup every hour to keep that fresh look going for you! Think of coordinating your looks. You may consider clear or neutral nails with no chipped polish on fingers or toes. It goes a long way towards presenting a professional look.

Photographers have unique skills. These skills are not simply their technical skills with the camera and lighting. People will say that the photographer 'has a good eye' or 'is really creative'. That means that they can see the model and the image that they want to produce in their mind before the shutter is clicked. Their originality must be protected. If a photographer has an idea, pose or setting and you like it, do not take it to another shoot and suggest the same pose to another photographer that you might like more. That's considered stealing. It's just down right tacky. And word gets around!

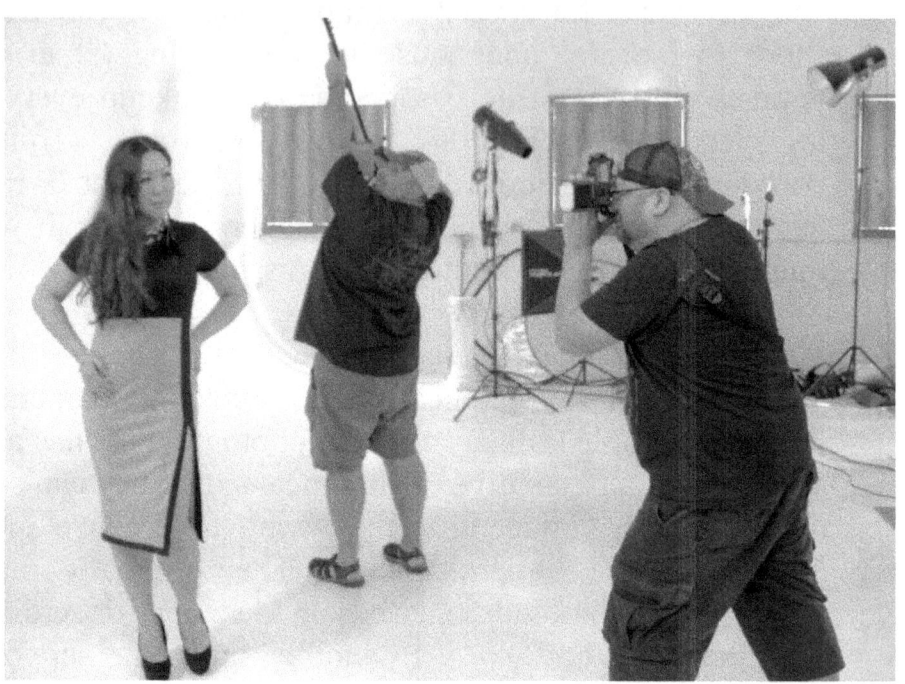

Capturing images is a creative process. Whether the model is in the field or at a studio the photo shoot can take on a life of its own. Photographers will spot a prop or the casting of a shadow that inspires them to place the model in a certain area to maximize the effect on the image. Go with the flow and even make suggestions to the photographer. Saying something to the effect of "I really like that scarf, I wonder if we can work that into the shoot?" helps the process.

It's important to change your facial expressions. Photographers want to get several 'looks' from you and those models who use several expressive looks get more call backs than those with one look. Try moving your eyes to the right or left while keeping your face still. Open your eyes wide and your mouth for that surprised look.

During the shoot, silently go through the vowels. When you mouth the letter 'A' you create a specific look. Then mouth the letter 'E' and you can see that your face changes. Go through the rest of the vowels while the camera catches you going through A E I O U…..and sometimes Y….

Photographers love models that can show emotion. So turn it on and let them see the emotions that you can display. Remember when you are going through your various poses to stop and freeze so that the photographer can catch a clean image. If you keep moving the photograph tends to blur. So get in that best position, pose and pause for the photographer. It's a team effort!

The Make-Up Artists (MUA)

These artists have spent years perfecting their craft. They practice, practice and practice. They constantly seek new techniques and applications. Most women learned to apply makeup from their family and friends. Make-up artists add to this basic knowledge by taking courses and studying the craft. They build up their make-up kit of products that they have used or developed. One part of the kit may be filled with material to do a glamour shoot that would make Marilyn Monroe proud. The other side of the kit holds everything that is needed to turn Marilyn into a Zombie-like creature with small horns growing out of her spine!

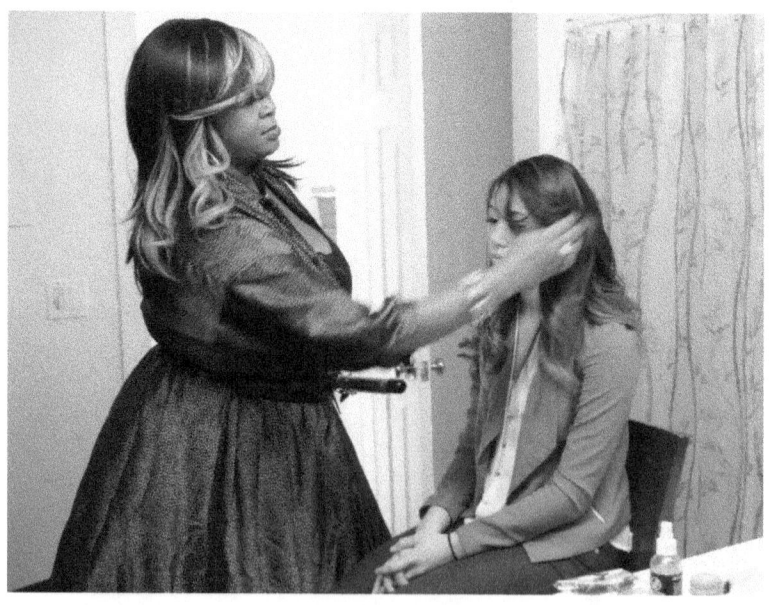

(Model: Lana Teh and MUA Marjani)

The make-up artist usually will ask new clients if they have any allergies. This is important because the scene may call for a prosthetic made of latex, or small latex bullet scars.

If the model has a latex allergy the make-up artist needs to know so that latex can be avoided. If you do have an allergy, be sure to tell the artist as soon as you sit down.

Hair Stylists

Like the Make-up artists, these people can make you look fantastic! Well sculpted hair can add a lot to the overall image and helps to tell the tale. Hair stylists have spent years mastering their craft and practicing. If you are doing a 1950's themed pinup shoot, the hairstyle must match the era!

Tell the stylist what look you are trying to portray and if you will be shooting static or dynamic. A static pose involves little action, your head stays in one place as it would in a portrait setting. Dynamic shots, on the other hand, involved movement. Not just turning the head from side to side. The photographer may want you to lean forward with your head in front of you at the knees, then rapidly bring your head up to the full standing position in order to catch the hair in motion. This probably will take a few tries. Or he may want to use a fan to give life to long hair in the shot. Or you may be running from zombies who are going to be pulling at your hair!

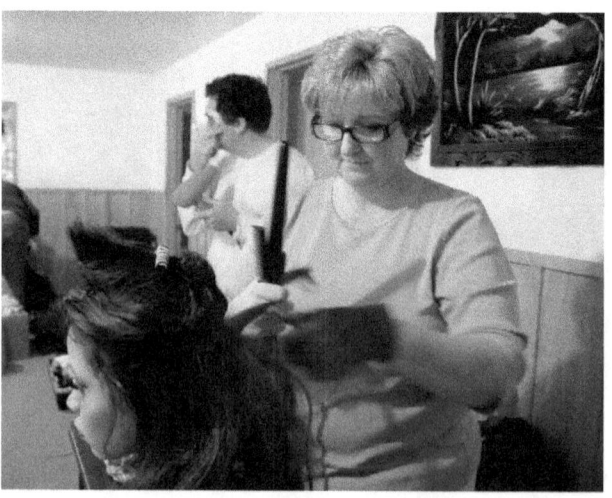

Hair Stylist: Pincurls by Tracy

Always show up at a shoot with freshly washed, clean hair. If you have weaves or hair appliances that you've used before, bring them to the shoot and ask the stylist to help put them in your hair.

Locations

Where the photographer shoots is a huge decision. It affects lighting and equipment as well as having financial considerations.

A studio location allows the photographer to control the lighting, wind and all sorts of other distractions. Usually the studio photo shoot will involve one or several models. There are normally accommodations such as a rest room and changing area that makes it a pleasure to concentrate on getting the right image.

Field locations can be more challenging. Seldom can the photographer control wind or light. Or rain... Sometimes on a public location such as a field or beach they can't even control the people or animals that wander into the frame! Bathrooms can be scarce or non-existent and the changing area may be the back seat of your car!

Studio or Field Location?

A studio is a large fixed expense for a photographer. Rent and utilities alone drive the monthly cost into the thousands. For this reason a lot of photographers do not own their own studios. Many photographers start out working from their homes, then expand to field locations and finally try to set up a photography studio. Many of them last a year or so. Rent and utilities must be paid and if they run into a downturn in business they end up selling their equipment. The days of Portrait Studios are almost gone with a nod to the cell phone cameras that take excellent photos.

Renting a studio is an option or even using a quality hotel room as a setting for glamour shots is common. Some of the Rental Studios in the Seattle area:

For a more complete list, check out: http://www.chytilphoto.com/studios2.asp

UrbanlightStudios Greenwood Phinney 206-708-7281
8537 Greenwood Ave N. Suite 1, Seattle, WA 98103
info@urbanlightstudios.com
http://urbanlightstudios.com/studiorental
Upstairs rental $100 per hour (2 hour minimum) $600 per day (8 hours) Downstairs $50 per hour (2 hour minimum) $300 per day Includes Dynalite strobe package, modifiers, grip package

Capitol Hill on 10^{th} and Union 206-650-0595.
400 square feet at 1216 10^{th} Ave, Seattle, WA
Hourly rate: $35 per hour (two hour minimum) Half day $125 (4 hours) Full day (8 hours) $200

Gasworks Gallery 3815 4^{th} Avenue NE, Seattle, WA 98105
Two fully equipped studios beginning at just $10 per hour near Gasworks Park on Lake Union. Free parking http://photostudiosforrent.com/

Royal Flash Studio 682 Industry Drive, Tukwila, WA 98188
Several fully equipped studios with props and lighting for glamour, commercial and green screen.
www.royalflashstudio.com 206-390-0969

Many Trade for type shoots are done in field locations such as National Parks which allow free use of some pretty spectacular back drops. One of the downsides of using public lands is the lack of control. Some cities require photographers to apply and pay for a photography permit before they can shoot professionally. So watch it if you are shooting in Portland, Oregon!

Setting up the shoot

Think of the photo shoot as a tiny theatrical production wherein the final image will tell a story. Often the photographer will have an idea in mind for a set of images. A glamourous lady posing in front of a lake with the wind pulling gently at her hair as if she is waiting for her lover to return from afar. Perhaps a nervous mode is, looking furtively around the corner of a building as if she is hiding from a secret agent.

As a model you can help the photographer set the scene. Try to select an area where the background is clear and clean. There is no point in shooting at a forest when the background is cluttered with cars in the parking lot and a porta-potty. Look for settings that will augment the look you are going for.

Be aware of the sun. Photographers usually shoot with the sun behind them. That means that you are going to be looking into the sun. Perhaps an early morning or evening shoot would work best. A leafy canopy of tree branches can diffuse the harsh sunlight.

Remember that the photographer is in charge of the shoot. Don't be afraid to make suggestions, but don't let the suggestions slow down or impede the shoot. Some of the ideas that you come up with may already be in the photographers mind. The photographer is checking the light and setting to capture the perfect image.

At the beginning of the shoot when everyone is getting ready is the time to announce that you have a special gown or special prop that you'd like to incorporate into the shoot. A special pose that you'd like to try should be brought up early in the event.

Basic Wardrobe

Most models provide their own wardrobe for basic shoots. That wardrobe could consist of blue jeans and a T shirt to a formal gown, heels and a Tiara! Since correct fit is essential on a photographic shoot many models have their own costumes and tailor them to accentuate their form. Iron them before you head to the shoot!

Think about how the photo shoot is going to unfold and be prepared for it. Often models show up for a shoot and discover that the weather is chilling. Wise models bring something to wrap up in while the photographer is adjusting settings on the camera or setting up the scene. A nice beach photo shoot with swimwear is often done on a chilly sandy beach with wind coming in off the ocean!

Model Roux Lette was provided with a coat and pistol for this shot in the Seattle Underground.

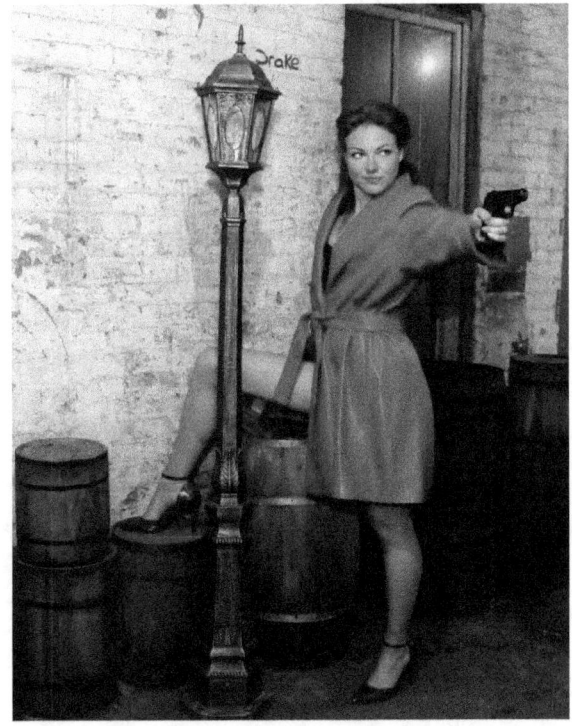

Consider your wardrobe as well. Leggings and tights have become popular and some of them tend to be sheer. These are all right in a studio or on a street. However, when bright lights and flash units go off, this type of clothing that the model is wearing tends to become translucent! Or see through. So if you decided not to wear panties to reduce that panty line on the photo, the photo shoot may move from a PG rating into an R rating rather quickly!

To get the most out of a small amount of clothing consider the following essentials:
- Comfortable, warm robe to keep warm in between shooting
- Black open toed shoes-other colors are tan, silver or white
- Tall pair of comfortable boots
- Assortment of undergarments, White underwear, Black underwear
- A little black dress
- Dark wash jeans
- Leather jacket
- A nice corset
- Seam free strapless bra
- Nude stockings that match your skin tone
- Headscarf to put on your head to avoid messing your hair when changing

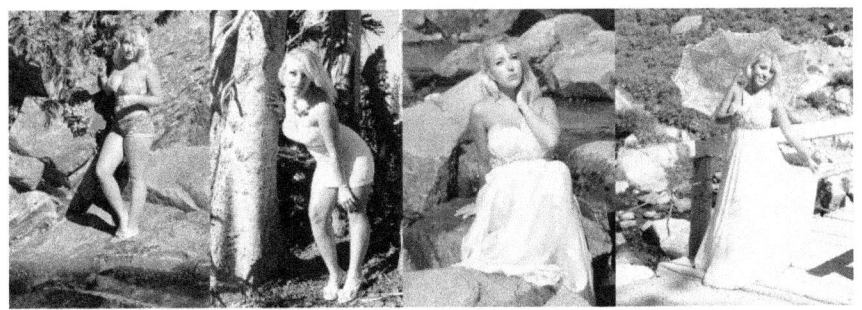

Model Grace Baird demonstrates how wardrobe can affect a photo shoot with these scenes taken at the Ranier National Park. She transforms from a casual pose to a sophisticated scene to a formal gown with an umbrella as a prop within hours at the field location.

Basic Props

For God's sake do something with your hands! By placing an apple, a sword or a feather boa in your hands you begin to tell a story. Jewelry is also an important asset to bring to a shoot. You may consider bringing a step stool and an umbrella to your shoots:
- Jewelry- a bold necklace or a cuff bracelet
- A nice umbrella
- Scarves
- Candles
- Candelabra
- Soap bubbles
- Glasses – need not be prescription- for that librarian look

 (Model Nana Kim shows how to use an umbrella for multiple poses.)

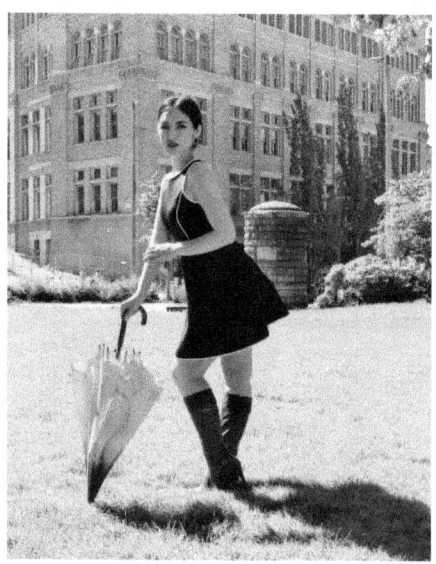

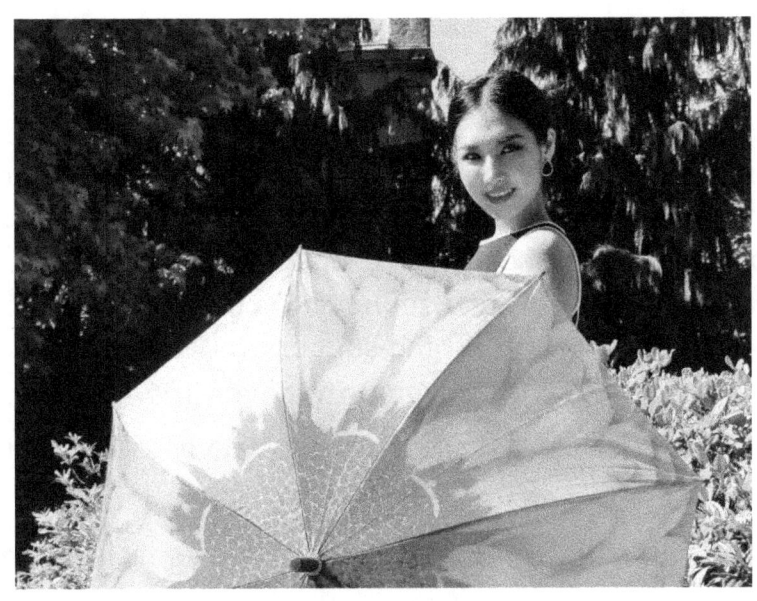

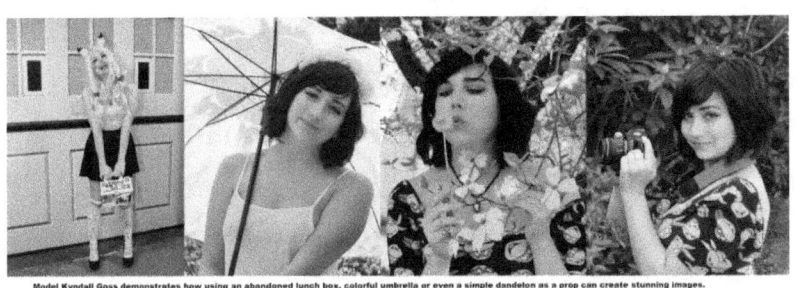

Model Kyndall Goss demonstrates how using an abandoned lunch box, colorful umbrella or even a simple dandelon as a prop can create stunning images.

Basic Modeling Emergency Kit

Also known as a 'gang box', this kit is a collection of things that you should bring to a shoot all the time. It's a little emergency kit that can save the day when a button pops off or you need to fix something on the spot. A nice sealable Tupperware container keeps it all from bouncing all over in your car. Some suggested items are:

- Makeup Concealer to cover imperfections
- Makeup A color stick to add color to your eyes, cheeks and lips
- Makeup Lipstick, mascara, eye lashes and glue.
- Q tips to fix make up smudges
- Lip balm to keep your lips from chapping
- Facial tissue/Hand sanitizer
- Cuticle eraser will keep your hands looking great!
- Small nail grooming kit – clear nail polish
- Eye drops can keep your eyes from watering during the shoot
- Comb or brush- To keep your hair perfect during those two hour shoots
- Hair Pins/clips/Bobby pins
- Hairspray and brush
- Gaffers tape (not as sticky as Duct tape to hold things in place)
- Lint Roller/Lint Brush
- Sunscreen

- Mirror- Check yourself out before the photographer shoots!
- Gaffer Tape Better than 'duct tape' for holding things together, the adhesive doesn't damage anything and comes off easily, even off skin!
- Double sided tape
- Safety Pins- To hold wardrobe together for the shot
- Sewing kit- To repair small tears that may develop
- Clothes pins
- Small scissors
- Bottle Water
- Towel
- Breath mints
- Deodorant
- Dental floss
- Face wash
- Hand lotion/Moisturizer/Wet Ones
- Razor
- Rubber Bands
- Tweezers
- Blanket/Robe/Coat
- Slippers or flat shoots for walking between shoot locations
- Snacks/Bottled water
- Towels (shooting near water?)
- Insect repellent

- Band aids In case you start to bleed on those rocks!
- Phone Charger
- Pen and a small notebook
- You may even consider getting a portable changing tent to change in!

Basic Poses you should master

Standing

This simple pose is used often for portraits and is good for just about any shot. Your
Shoulders are squared towards the photographer and the arm on the right is in an up and down position. To create a more casual look a jacket is draped over the models right shoulder. This brings that arm up, further breaking up what would otherwise be a linear image.

This pose can create a multitude of options for the photographer by simply shooting from different angles. (Model: Mimi Parks)

This image was taken at the same shoot. Still standing, the model has moved beneath a tree and has added an umbrella as a prop.

She has broken up the straight lines by angling her head and moved her arms to a horizontal position to change the dynamics of the image.

(Model: Mimi Parks)

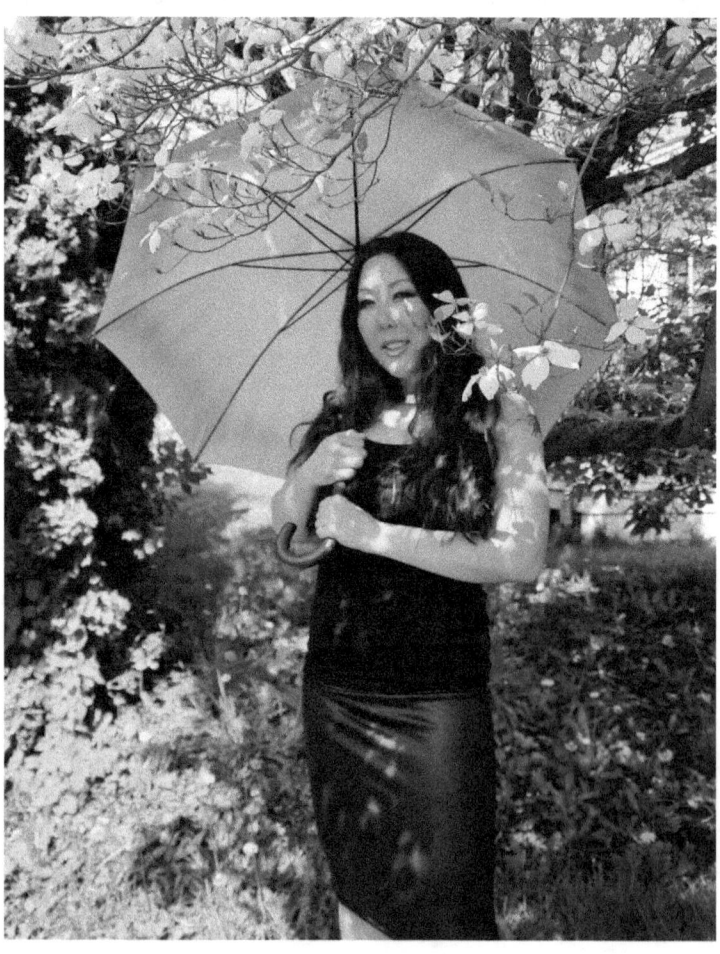

This model is using the graffiti background to create a 'tough girl' effect. Her body is slightly angled; one hand is raised higher than the other on her hip. Note the hip being tossed to one side.

(Model: Chelsea Wilson)

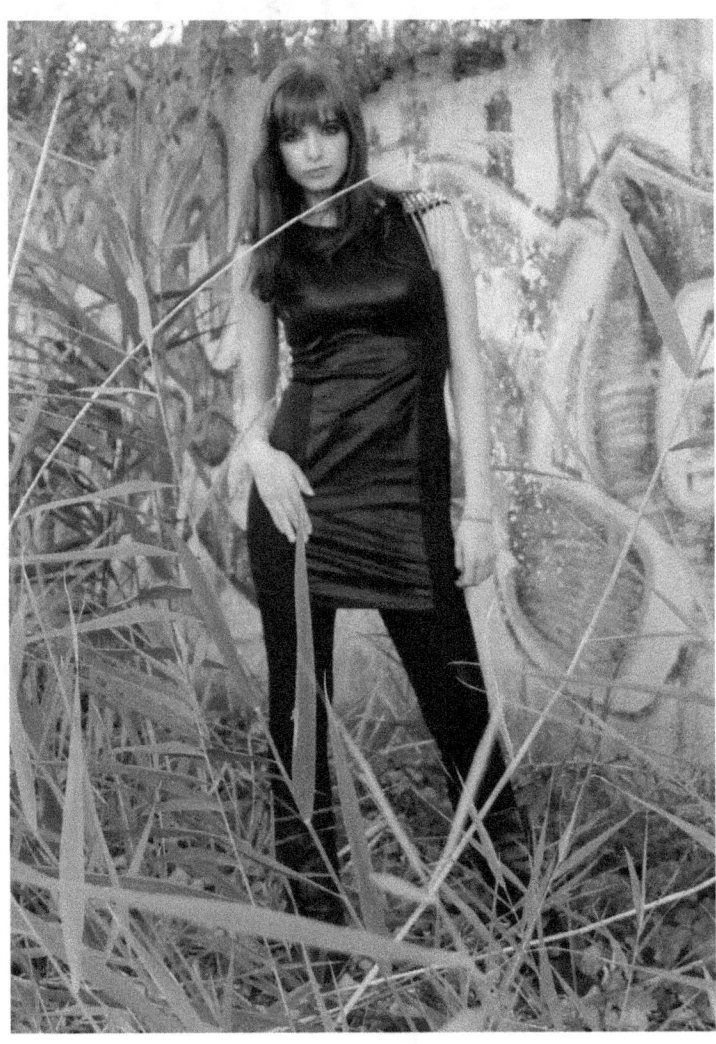

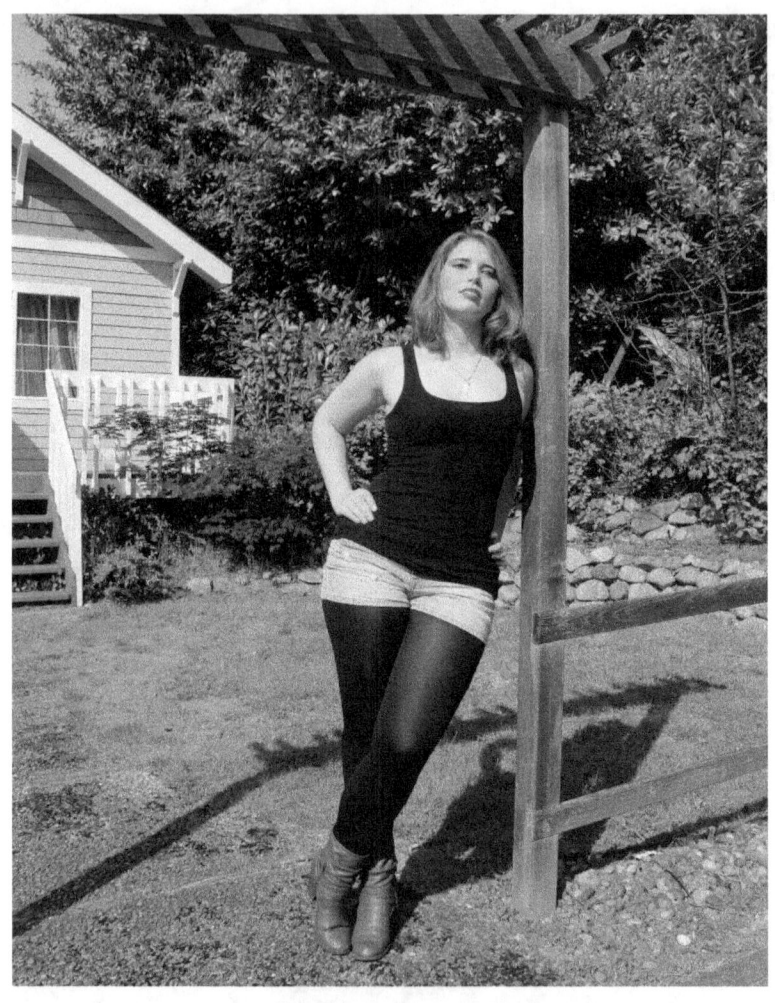

This image shows the model using the post as a means of support. She can lean against it, raise one leg against it or simply put her hand on it. All of these bring action and creativity to what could have been a static pose.
(Model: Tasha Alexander)

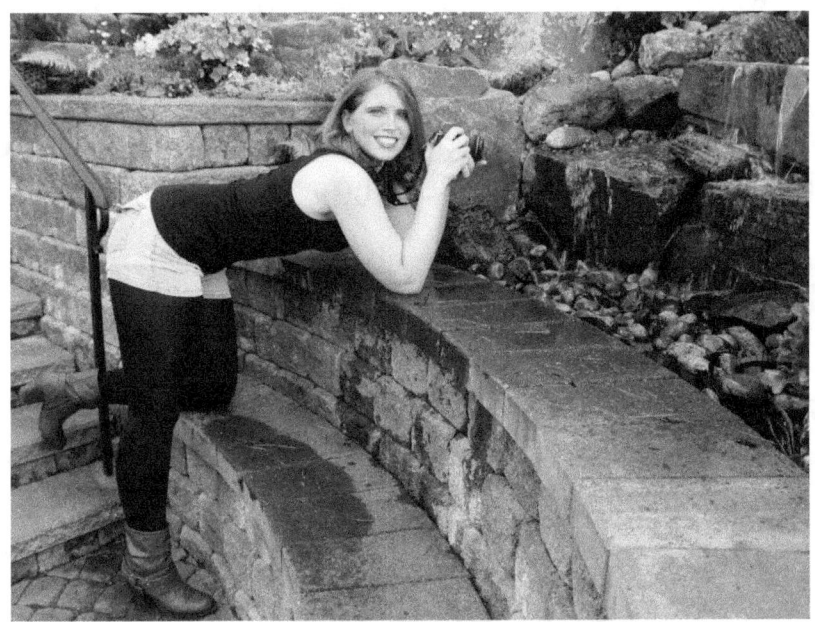

Standing with the brick wall of the fountain as a support, this model has broken up the lines of the image with her arms holding the camera. Her upstage foot is horizontal creating a casual look.

(Model: Tasha Alexander)

Work with other models on the shoot to create interesting shots such as this one. Both models are playing off the light in Tacoma's Spanish Steps, creating a relaxed, fun look for the shoot that would be less effective if done individually. Photographers enjoy working with models who 'play well with others'…

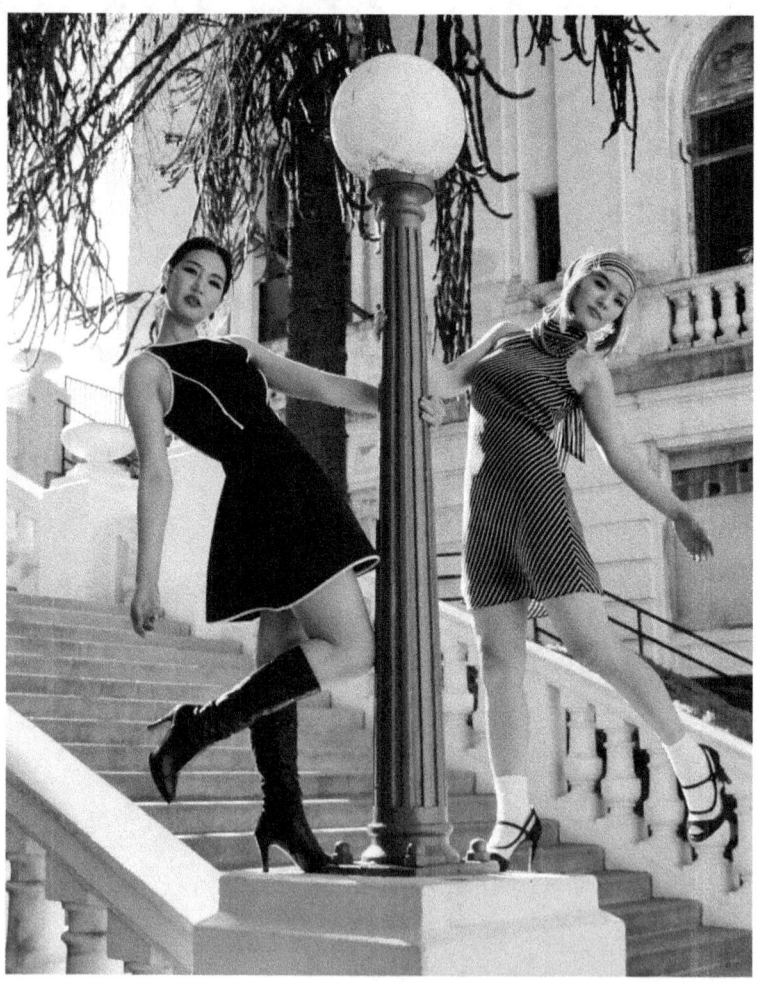

(Model: Emma Kim and Rachael Nakashima)

Sitting

This delicate pose can also pass as a 'behind the scene' image. The photographer has focused on the models image in the mirror, while capturing her face is doubly visible in the portrait. (Model: Marie Claude Sampson)

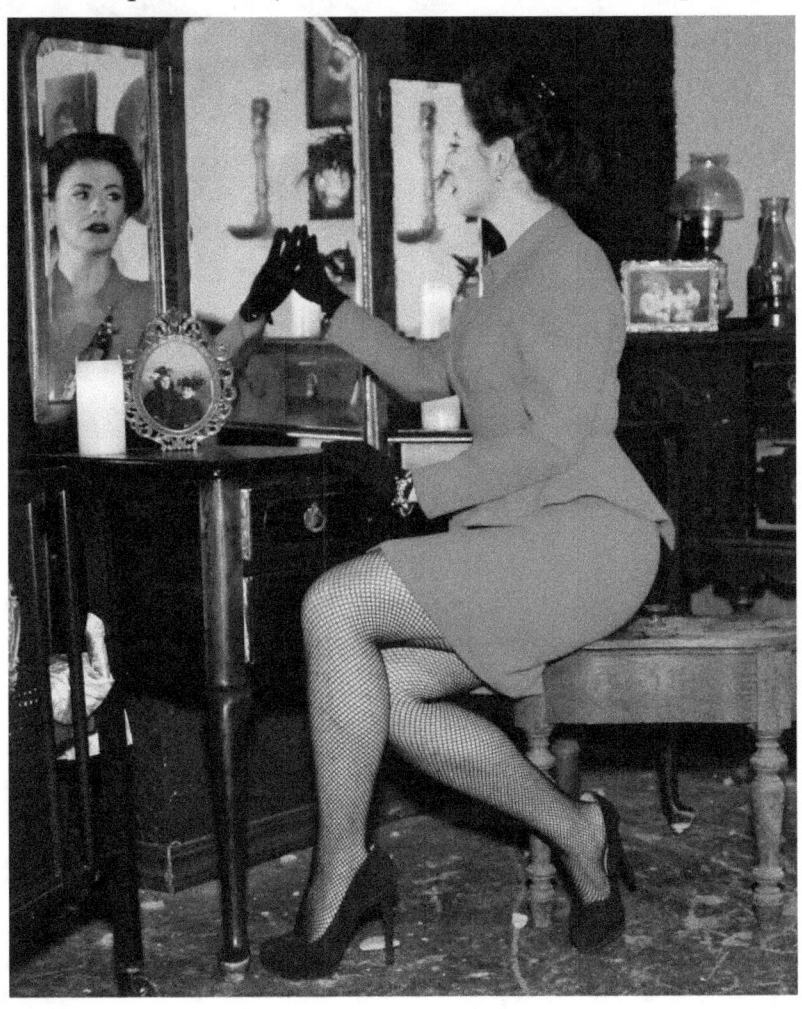

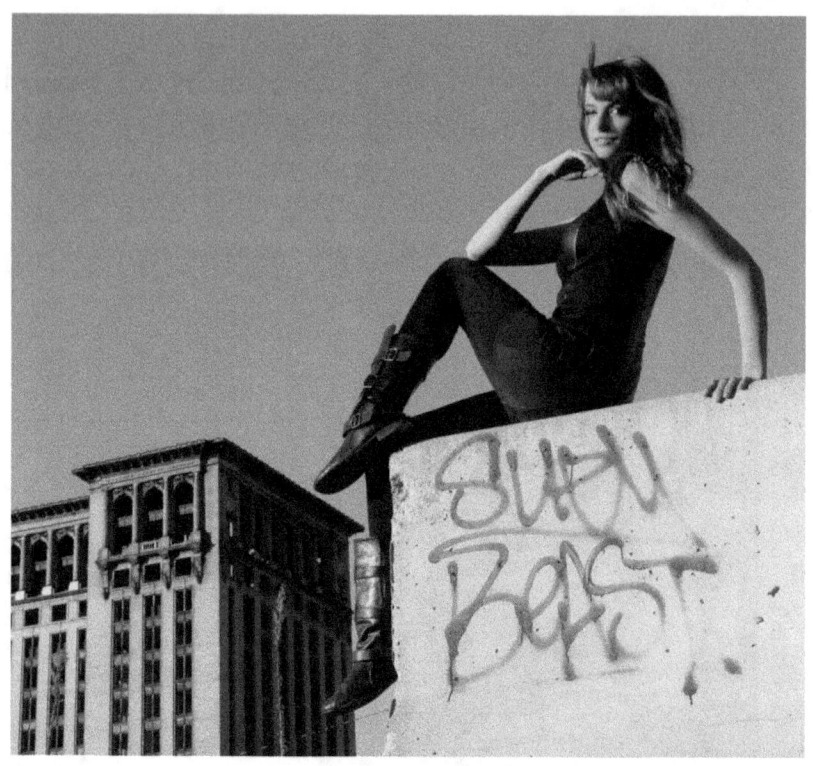

Using the urban Detroit train station as a background, this model has contrasted the straight lines of the ruined building by creating angles with her legs. Her arms are also poised to catch the sunlight and she is facing into the wind so that it can play with her hair.
(Model: Chelsea Wilson)

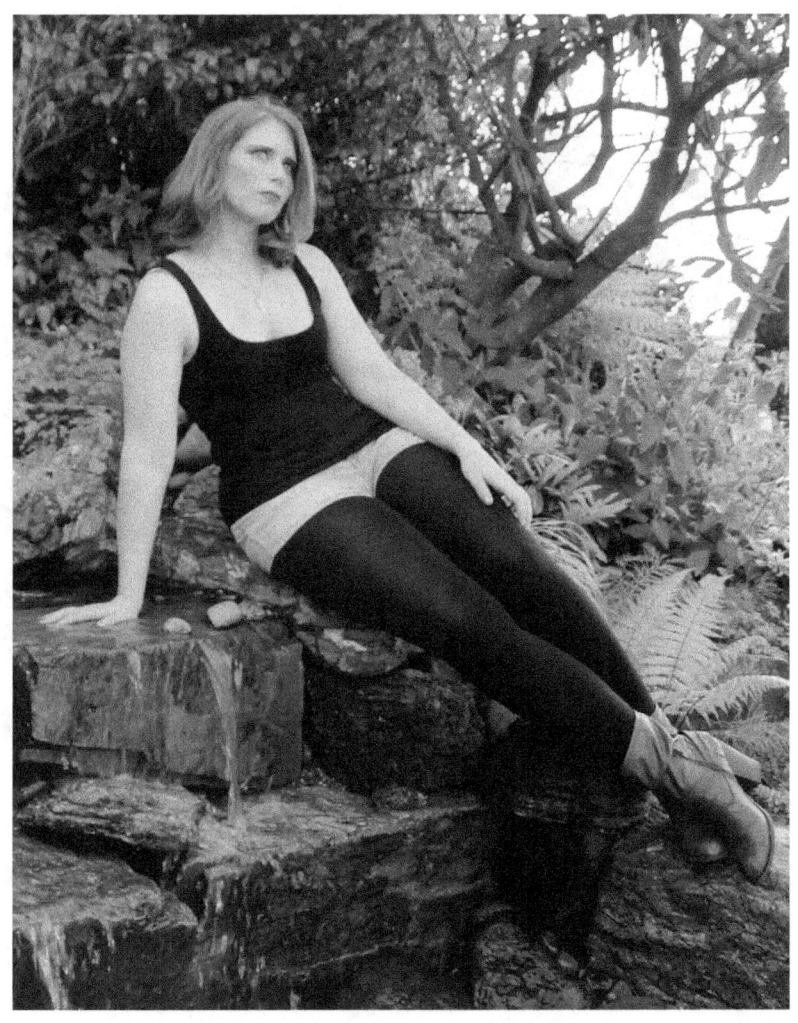

Sitting by a cool stream with one hand in the water presents a vertical image, while the other hand relaxes on the models leg to break up the square look. A slight tilt of the head finishes the image.

(Model: Tasha Alexander)

Lying

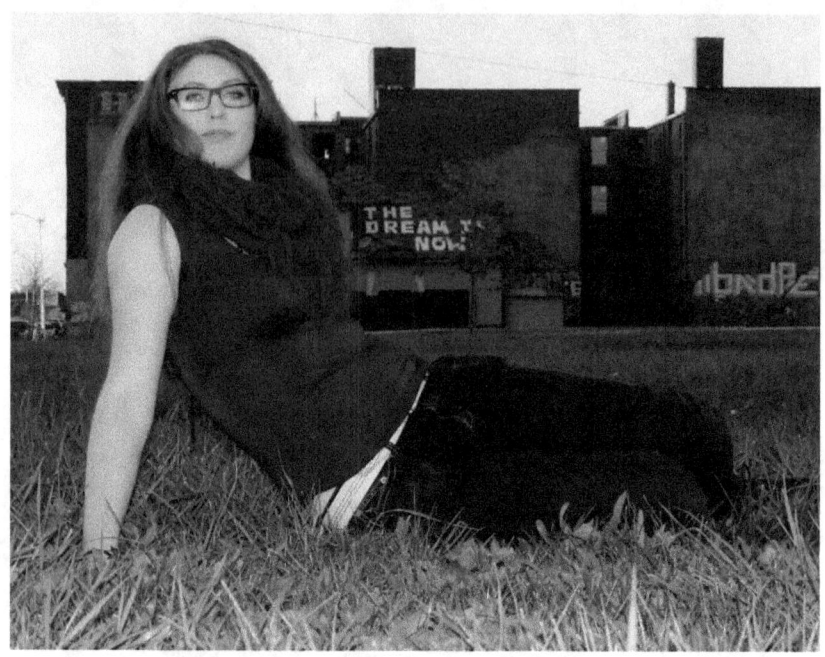

This model is lying on the grass with an urban decay setting behind her. The photographer got on the grass and took the image from the ground up.
(Model: Amanda Davies)

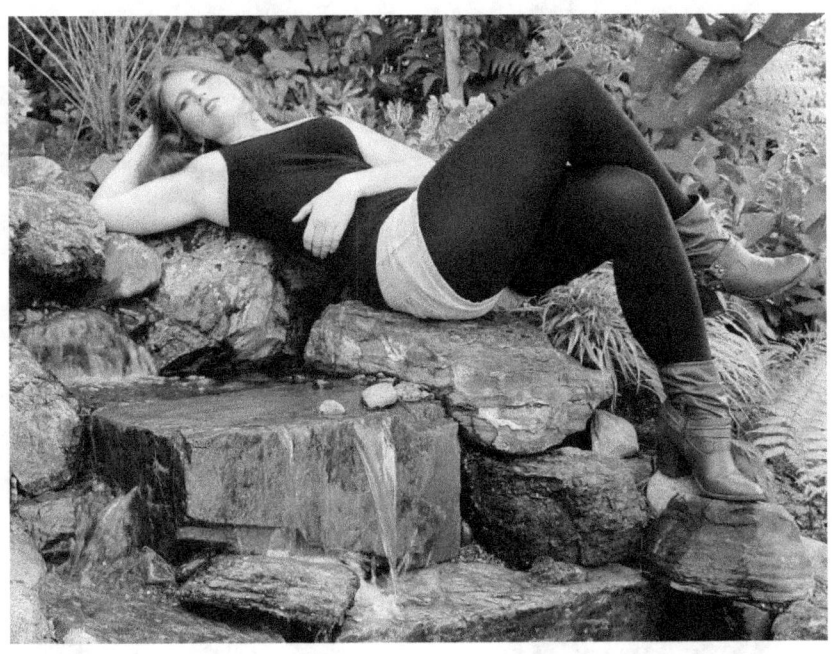

Using the incline of the rocks that surround a fountain this model breaks up the horizontal and up and down framework to create a relaxed setting. Her left arm is draped across her stomach while her right arm supports her head.
(Model: Tasha Alexander)

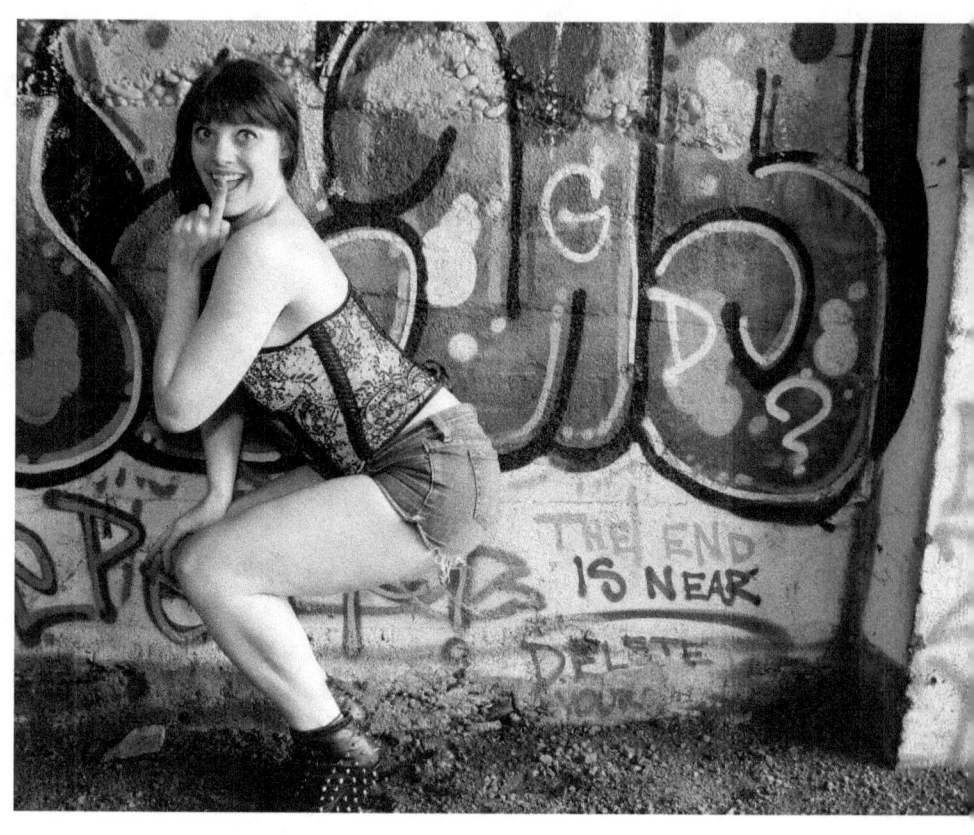

(Model: Stephanie LeAnn)
And don't forget to have fun!!!

Sample Business Plan

Overview of the Operation

A. Mollie Model has been successfully providing make up service to clients since 2012. Seattle Modelling Effects is an umbrella organization to control multiple revenue producing enterprises in the make up artistry industry.

The primary enterprise is doing make up for models and modeling agencies.

Other revenue producing streams include event coordination and modeling.

Background & Critical Success Factors
Introduction

 a. This is a newly formed company. The purpose of the organization is to expand modeling operations into a more effective revenue stream.

 b. The purpose of the company is to modeling services to photographers who pay the images.

Additional services will be added to the company as the company grows.

 c. One day themed photographic events will be offered in local areas for photographers and other models and makeup artists.

 e. The objective of the company is to provide a minimum of four modelling jobs every month, for a total of forty eight gigs in a year. The company will host a minimum of two photographic events each year.

 f. The benefits of this type of modelling service is bringing a bright young new face to the fashion and advertising industry.

Business Environment

 a. The modeling and makeup industry is one of the more lucrative industries in the United States

 b. The services that we offer are professional modelling.

 c. The local market consists of the professional modeling agencies as well as the growing amateur market who attend themed events such as Cosplay, Fairyworld, Steampunk and Crypticon styled conventions.

 d. The closest competition is every other model in the area.

Risks & Opportunities

a. The strengths that Mary Model has in this venture are the two years of experience in the modelling field. Additionally, training and classes have been attended to improve the models skill set.

b. The weakness in this concept is the initial newness of the startup operation.

C. Description of services & products- Sources of revenue

1. Initial services will consist of modelling for photographic and video venues. Additional services may include event planning for future themed photo shoots

2. Uniqueness and Special Aspects

What makes this service unique and different than others?

3. Product Strategy

How do you plan to kick into the market?

Product Strategy- Mary Model will develop and market the company in a variety of way using social media, printed material and pursuit of modelling agencies.

Facilities & Equipment

- Offices- Are located at 355 Theodore Road, Seattle, WA.
- Equipment and supplies – Listed in Appendix

MARKETING PLAN

Goal: Maintain current customer base while expanding markets to attract new customers.

Marketing Objectives:
- Maintain current customer base. Increase incoming requests by 25% by the end of the year.
- Develop new markets

A. A test market was performed from October-December. No advertising was done with the exceptiion of word of mouth advertising and Facebook. The positive response indicated a definite market for this modelling service.

B. Maintain a demand for the product by alternative themed events. On a bi-annual basis promote and host a Photo Shoot to highlight the modelling quality and skill.

C. Market analysis

1. Economic Environment- The area is in a growth pattern for these services as the area leads the nation out of the recession...

2. Industry Environment- Disposable Income

3. Customer Base- Any

4. Market Size, Geography- Concentrate on the Western half of the state.

5. Market Share- In this area there are xx mua and xx event promoters

6. Target Market

7. Market Needs Analysis- Conducted in early 2016

8. Market Opportunity- Perform a trend analysis

9. Government Regulation- This business is not highly regulated...

D. Competition- At this time there is competition in the local area.

E. Sales Tactics- Model and makeup promotion will be done using the internet, facebook and application at local agencies. Rather than compete for like products, the company should differentiate itself as a provider of premiere makeup application and events. Event promotion will be done using faceook, blogs, web site and promotional material distributed at local venues such as Glazers camera shop in Seattle, Crypticon and Steampunk type conferences...

F. Pricing- All prices reflect a minimum of two hour commitment.

$50 per hour Normal photo shoot on location or in studio
$65 per hour Implied or topless in studio
$75 per hour Implied or topless on location
$100 per hour Nude in studio

G. Promotion- All handout material with the exception of the comp card will have our name and address on it. Self promotion will use social media such as facebook and model mayhem internet sites to advertise by posting images of my work.

Social Media – Facebook, Twitter

TF Shoots

Business card

8x10 photographs

Runway shoots

Conventions

Flyers and brochures posted at local camera shops

Sources of quality printing and reproduction

III. MANAGEMENT & OPERATIONAL PLAN

A. Management Team

The organization will be operated as a sole proprietorship with the owner being the operator and only person in the company. Other personnel may be hired to provide assistance in setting up rooms, marketing and making arrangements on a fee basis. Supporting professional services will be contracted out.

B. Human Resources

Personnel involved with this company are required to maintain a professional demeanor.

C. Facilities & Equipment

1 Offices- Are located at 355 Theodore Road, Seattle, Washington

2. Equipment

a. Production equipment includes a make-up kit, wardrobe, modelling kit, lights, background equipment and props.

Pricing

Average fee for this type of service is $50-$200 per hour. Our beginning fee of $50 is on a par with those sessions.

Promotion- Web based and word of mouth, limited direct mail. All handout material should have the Mary Model name and address on it. (Need to develop a recognizable brand. Perhaps incorporate the Space Needle and monorail if you are Seattle based. If you are based in St Louis, perhaps the recognizable arch would be a good image to consider.)

Packaging- Physical package- Handout material will be bound and branded with the Mary Model brand. Each item going out should include a catalog or flyer of upcoming events.

Free advertising of upcoming sessions: Post in photo shop bulletin boards

Local photographic groups may put the events in their newsletters:

Thoughts on how to maintain current customer base
- There is currently no branding for our product line. Need to develop a logo and support material. Put logo on shirts, pens, papers, etc.
- Establish a look and feel for the artists. Perhaps an apron or smock with the company logo.
- Dress appropriately. Establish a look for the Mary Mode Company. Blue Jeans and button down shirts or khaki's and Polo shirts? Offer carry bags to clients at cost with Mary Models logo.

Thoughts to be included in the publicity plan:

Develop a Publicity Plan that includes press releases, media advisories, press kits, fact sheets and public service announcements. These should be in an easy to use format. Define the plan with a description of your unique features, as well as services. Define public relations objectives and where they stand currently, what your company is doing to promote itself, current brochures, things like that. List the audience to reach and how much coverage Mary Model wants, such as a monthly publicity news release, radio comments and things of that nature.

- Rebrand the Web site-
 - Address should be easy to remember such as WWW.Mary Model. Provide links to useful sites such as PNTA, Model Mayhem
 - Free downloads on site
 - Calendar of events, how to contact
 - Local newspapers- develop a press release and send it to them
 - Links to local partners and consultants who support the company
- Establish a Press Release complete with a nice black and white photo that can be provided to organizations and newspapers. Black and white copy is nice because they can simply send it through a copy machine and make their flyers.
- When attending any meeting, remember that the purpose is to network. Be prepared to chat briefly about your business and get your foot in the door. Always be prepared to present your business card and comp sheet to the client.

- Use the local media to promote the modelling. Local newspapers and magazines can help promote the company in the region. Mary Model may want to use radio and television press releases to promote itself on news shows, talk shows and other methods of media release.

Thoughts to consider in the plan
- Write a press release to re-establish the Mary Model in town.
- Initiate a "Makeup Corner" column in the newspaper.
- Conduct a free workshop in Seattle. Give a speech to the chamber of commerce, Rotary Club, and Lions Club.
- Write an article for the local newspaper or a magazine.
- Develop a press kit. Send to target media and follow up with phone calls.

Appendices

(These are areas that you should develop to meet your plans)

A. Schedule of Major Events
B. Facilities & equipment data
C. Fee Structure
D. Marketing Themed Photo Shoots
E. Press Releases
F. Monthly Marketing Targets
G. Reproducible Forms (model release, liability form, etc)
H. Personnel and Resume
I. Ideas for Themed shoot and locations
J. Sample Concept Paper for setting up a Themed Photo Shoot

Appendix A to Business Plan
Schedule of Major Events

January	4-Haunted New Year Shoot in Seattle
	17-19 Rustycon – Sci Fi convention Seattle Marriott Rustycon.com
	19 ICE Queen Shoot in Oregon
February	21-23 FaerieCon West Seatac Doubletree Hilton
March	St Patrick's Day Bunny hop
	Employee Appreciation Day
April	Easter
	12-13 Norwes Con Science Fiction Convention in Tukwila
May	24-26 Crypticon Horror Convention - Seattles largest horror convention with a make-up artist contest (Makeup artist competition) Booth cost $300…Could do a photo shoot and sell prints
	Mothers Day/Nurses Day
June	21 Flight of the Fairies
	21^{st} Summer Solstice/Father's Day
July	Independence Day
	Classic Car Photo Shoot in Des Moines
August	National Aviation Day
September	
October	25-27 Steamcon III Bellevue Hyatt Regency
November	15-Thanksgiving/Veterans Day
December	Holiday Season
	Don't forget to send holiday cards to clients.

The next year…

January Rustycon
February Fairiecon West
March St Patrick's Day Bunny hop Employee Appreciation Day
April Easter
May National Nurses Day
Crypticon Horror Convention (Makeup artist competition) Seatac Mothers Day
June 21st Summer Solstice Father's Day
July Independence Day
August National Aviation day
September
October Steamposium in Seattle Halloween
November Thanksgiving Veterans Day
December Washington's Birthday, Christmas, Hanukkah, Pearl Harbor Day

Appendix B to Business Plan
Facilities & Equipment

Item Description	Value	QTY	Total Value
Service Items			
Makeup kit-	$300	1	$300
Assorted brushes	$200		$200
Airbrush system	$500	1	$500
Wardrobe			
Shoes/Gowns etc	$400		$400
Props			
Jewelry/Glasses	$ 75		$ 75
Carrying Cases			
Duffle Bag and hard case	$200		$200
Office Items			
Laptop Computer	$600	1	$600
Chairs	$50	2	$100
Coffee cup coffee maker	$75	2	$150
(One for coffee, one for hot water for tea)			
Total Value of Assets:			**$2,425**

This is a listing of the property that the organization owns. It may seem trivial when you are starting out, but the insurance company that insures your business will want this information (along with serial numbers, etc) if there is an accident or damage.

Also, when you decide to incorporate, you will be asked to determine the actual value of your company. This goes for those small LLC (Limited Liability Corporation organizations). These firm assets will give you a nice starting figure. The value of your corporation is the sum of all of its owned assets, so keep track of them from the beginning.

Appendix C to Business Plan
Expense Budgets/Fee Structure
Modeling Fee Schedule
 $50 per hour Normal photo shoot on location or in studio
 $65 per hour Implied or topless in studio
 $75 per hour Implied or topless on location
 $100 per hour Nude in studio

Corporate/Group Rate:
For photographic clubs and groups the rate is $500 per day for a studio session.

Fee for Photo Shoot Events set up by me
Photographers pay $50
MUA pay nothing (They get to keep tips from their own tip jar)
Models pay $10

Funds will be deposited into a Business Checking Account
Receiving funds – Paypal and Square

Appendix D to Business Plan
Marketing Themed Photographic Shoots
List of advertising/marketing contact information
Facebook channels- Artistic Clique, Event page
Model Mayhem-
Glazers Camera Shop in Seattle
Kenwood Camera Shop
Talls Camera Shop
Magazines:
Submit photos to Seattle Magazines

Publish Dates and Places each month. Send announcements to pscalendar@asse.org for example:
- Seattle Times and Post IntelligencerBusiness Section – People on the move/Calendar submit calendar items two weeks in advance to businesscalendar@seattlepi.com OR Seatte P-I business News, PO Box 1909, Seattle, WA 98111-1919
- Puget Sound Business Journal: fax 206-447-8510
- KIRO TV news fax 206-441-4840
- KCPQ TV news fax: 206-674-1777

Local Associations: Consider joining and attending meetings

Appendix E to Business Plan
Press Releases

Sending a press release to the local newspaper, television or radio station is a good way to get free publicity. Remember that the newspaper editor is fighting to fit a lot of information into the paper that only has a certain number of pages. So don't be upset if they don't publish your release when you want it printed, or if they just don't have room for it.

To increase your chance of getting your press release published, Purchase some advertising from the paper from time to time and become known to them as an advertiser as well as a contributor. Always include contact information so that they can contact you for additional information or set up a photo shot.

The press release should be no longer than two pages, double spaced so that the editor can do a quick scan of it. If there are numerous events to publicize, consider sending two releases several weeks apart from each other. This helps to build your name recognition among the media contact people.

The release should have a compelling headline that catches the eye of the person who is going to read hundreds of these things a week. Keep it about seven words in length about one-third of the way down the first page. If you are writing for the local news try something like: "Local model supports the veterans with a patriotic photo shoot" or "Model provides calendars to local veterans".

The press release should have a date on the front page so that the contact person knows that it is current, as well as a dateline that tells the city, state where the news is happening. The lead of your article should summarize the release in no more than 40 words.

The release should cover the Five W's of advertising: Who, What, When, Where and Why.

- Who is conducting the event and who is it for- is it free or is there a charge?
- What type of training is being offered?
- When is the training being conducted, the day, start and end time of the session?
- Where will the training be held should provide driving directions or local landmarks.
- Why is the session being conducted explains to readers why they need this type of training.
- How to Register- email register@marymodel.com

PRESS RELEASE FROM Mary Model
CONTACT: Mollie Model 360-555-1212
Email: scott@marymodel.com

Seattle, Washington 14 May, 2016

Mollie Model XXXXXX in Seattle is hosting a themed photo shoot at XXX location on DATE:

Photographers, makeup artists and models will gather at 9am to prepare for different scenes that will center on the concept of Fairies in the Forest.

Press is encouraged to visit for some unique photographic views.

To register contact Mary Model at 360-555-1212/ Mary Model

PRESS RELEASE FROM Mary the Model
CONTACT: Mollie 360-555-1212
Email: Eve@Maryemodel.com

Seattle, Washington 14 May, 2016

Mollie Model –Jill Spratt has joined the technical staff of Mary Model!

Mary Model is pleased to announce that Jill Spratt has joined the staff as administrative assistant. Jack is looking forward to revitalizing Mary Model. She looks forward to expanding the number of quality photo events in the Pacific Northwest.

Jill can be contacted at: 360-555-1212.

Send announcements to news outlets;
- Seattle Times and Post Intelligencer Business Section – People on the move/Calendar submit calendar items two weeks in advance to businesscalendar@seattlepi.com OR Seatte P-I business News, PO Box 1909, Seattle, WA 98111-1919
- Puget Sound Business Journal: fax 206-447-8510
- KIRO TV news fax 206-441-4840
- KCPQ TV news fax: 206-674-1777

Appendix F to Business Plan

Monthly Marketing

A step by step method to promote your career

This should explain how you are going to maximize the events that you are attending and how to get clients. It should match the event calendar, but remember that advertising must go out 30-60 days prior to the event.

Events to highlight

December Resend Facebook invitations to everyone to remind them of the upcoming shoot in January.

January

Send Calendar Updates to Seattle newspapers. Send email to subscriber list.

Events to highlight:

January	Haunted New Year
February	Valentine's Day
March	St. Patrick's Day
April	Bunny Hop
May	Crypticon Convention/Mothers Day
June	Opening Day of Boating
July	Independence Day
August	Car and hot rod shows
September	
October	Halloween
November	Thanksgiving
December	Christmas Carols

Send Calendar Updates to Seattle Magazine.
Send email to subscriber list.

Send Press Release to Seattle Times Business announcing the establishment of your modeling business. Possible article for the Seattle Times with photo's of clients.

Appendix G to Business Plan
Reproducible Forms

Model Release Form

_____, _____,

(PRINT LAST NAME) (PRINT FIRST NAME)

(AGE)

I hereby irrevocably authorize all photographers participating in this event to use photographs of me and or my property and authorize him/her and their assignees, licensees, legal representatives and transferees to use and publish (with credit) photographs, pictures, images or portraits herein descried in any and all forms and media in all manners including composite images or distorted representations and the purposes of publicity, illustration, commercial art, advertising, publishing (including electronic format) for any product or services or other worked or artist rendering deemed lawful. These images may be published in any manner, including (but not limited to) calendars, advertisements, periodicals, and greeting cards. Furthermore, I will hold harmless the aforementioned photographer and his/her legal representatives and assigns, from any liability by virtue of minor cropping that may be required, and color and exposure shifts that may occur in reproducing this photograph.

Description of images: Each photographer may have a different and unique approach to the photo shoot. The general theme announced previously for the event will generally be followed. Some images may contain partial or full nudity at the discretion of the model as indicated below. Zero nudity or implied nudity is allowed for models under the age of 18.

By placing their initials in front of the limitations below the model is indicating what IS NOT ALLOWED IN PRINT OR PUBLICATION.

 _____NO See thru nipples
 _____NO topless or exposed nipples
 _____No full frontal nudity
 _____ Use Model Stage Name
_____on credits.

In exchange for my services as a model, each photographer for whom I do a photo session will supply me good and valuable consideration in the form of no less than four fully professionally edited images for my use in a portfolio or marketing of my services.

To that end I permit the photographers referred to above, licensees or assignees to use the images mentioned above, drawings or reproductions thereof, complete or in part, alone or in conjunction with wording and or drawings for Editorial, Experimental, Advertising, Public Relations, Packaging, Web Advertising, Display material, Books, Magazines, and future dissemination et al.

- Specific Exclusions: None
- Territorial Limits: Worldwide
- I understand that I do not own copyright of the photograph(s) referred to above.
- Copyright remains fully with the photographer, the original author.
- I understand that such copyright material may be deemed to represent an imaginary individual.

I waive any and all rights to approve or review any uses of the images, any written copy or finished product. I have read and fully understand the terms of this release. I further release the Photographer and his/her direct or indirect licensees and assignees, from any claims for remuneration. I am of legal age and have the full legal capacity to execute this authorization without the consent or knowledge of any other person.

Model mailing address:

Model City, State, Zip

Model Email Address:

Models contact phone number:

In accepting this model release the photographer and client undertake that the copyright material shall only be used within the terms of this release.

_____ Date _____
(Signature of photographer)
_____ Date _____
(Signature of model)

Sample
Photographer License Agreement

I,:_____, _____,
 (PRINT FIRST NAME) (PRINT LAST NAME)

am the photographer and copyright owner of the images described herein. In exchange for services rendered or consideration exchanged I hereby grant license use of the listed images to:

_____, _____
 (PRINT FIRST NAME) (PRINT LAST NAME)

These images may be published in any manner, including (but not limited to) calendars, advertisements, periodicals, and greeting cards. Furthermore, I will hold harmless the aforementioned person from any liability in the realm of copyright laws that may occur in reproducing these photographs. To that end I permit the photographers referred to herein, licensees or assignees to use the images mentioned above, drawings or reproductions thereof, complete or in part, alone or in conjunction with wording and or drawings for Editorial, Experimental, Advertising, Public Relations, Packaging, Web Advertising, Display material, Books, Magazines, and future dissemination et al.

- Specific Exclusions: None
- Territorial Limits: Worldwide
- Copyright: Remains fully with the photographer, the original author.
- Time Frame: In perpetuity

I waive any and all rights to approve or review any uses of the images, any written copy or finished product. I have read and fully understand the terms of this license. I further release the parties listed herein from any claims for remuneration not mentioned in this license. I am of legal age and have the full legal capacity to execute this authorization without the consent or knowledge of any other person.

Description of images

1. All images taken at this shoot and forwarded to the licensee by the photographer

2.

3.

4.

5.

6.

7.

8.

9.

10.

_____Date _____
(Signature of photographer)
_____ Date _____
(Signature of model)

Photo Shoot
Waiver and Release of Liability

In consideration of being allowed to participate in any way in the photo shoot event, related events and activities, the undersigned acknowledges, appreciates and willingly agrees that:

1. I will comply with the stated and customary terms and conditions for participation. If, I observe any unusual significant hazard during my presence or participation, I will remove myself from participation and bring such to the attention of the nearest official immediately; and,

2. I acknowledge and fully understand that each participant will be engaging in activities that involve risk of serious injury, including permanent disability and death, and severe social and economic losses which may result not only from their own actions, inactions or negligence but the action, inaction or negligence of others, the rules of play, or the condition of the premises or of any equipment used. Further, I accept personal responsibility for the damages following such injury, permanent disability or death; and,

3. I knowingly and freely assume all such risk, both *known and unknown,* even those arising from the negligent acts or omissions of others, and *assume full responsibility for my participation* ; and

4. I, for myself and on behalf of my heirs, assigns, personal representatives and next of kin, hereby release, hold harmless, the promoters of this event , its officers, officials, affiliated clubs, their advertisers, and, if applicable, owners and lessors of premises used to conduct the event, all of which are hereinafter referred to as "releasees," with respect to all and any injury, disability, death, or loss or damage to person or property, whether arising from the negligence of the releasees or otherwise, to the fullest extent permitted by law.

5. I do hereby give the promoters of this event, its assigns, licensees, and legal representatives the irrevocable right to use my name, picture, portrait, or photograph in all forms and media and in all manners, including composite, for advertising, for publication or any other lawful purposes, and I waive any right to inspect or approve the finished product, including written copy, which may be created in connection therewith.

I HAVE READ THIS RELEASE OF LIABILITY AND ASSUMPTION OF RISK AGREEMENT, FULLY UNDERSTAND ITS TERMS, UNDERSTAND THAT I HAVE GIVEN UP SUBSTANTIAL RIGHTS BY SIGNING IT AND SIGN IT FREELY AND VOLUNTARILY WITHOUT ANY INDUCEMENT.

_____,Date _____
(Signature of model)

(Signature of parent/ Guardian if under 18)

FOR PARENTS/GUARDIANS OF PARTICIPANTS UNDER 18 AT TIME OF REGISTRATION:

This is to certify that I, as parent/guardian with legal responsibility for this participant, do consent and agree to his/her release, as provided above, of all the Releasees, and, for myself, my heirs, assigns, and next of kin. I release and agree to indemnify and hold harmless the Releasees from any and all liabilities incident to my minor child's involvement or participation in these programs as provided above, even if arising from their negligence, to the fullest extent permitted by law.

PROPERTY/ LOCATION RELEASE

This Property/Location Agreement and Release ("Agreement") is dated _____ and is between _____ ("photographer") and the undersigned Property Owner.

Agreement as follows:

For good and valuable consideration of _____, herein acknowledged as received, the undersigned ("Property Owner") being the legal owner of and/or have the authority to bind the owner of, or having the right to permit the taking and use of, the photographs of certain property identified as :

Place:

agrees that the photographs of the property identified above may be supplied by the photographer or his or her licensees or assigns to any person for any use whatsoever, whole or in part, in any manner, without seeking further permission or consideration.

The undersigned hereby waives all rights and releases Photographer and its assigns from, and shall neither sue nor bring any proceeding against any such parties for, any liability, loss, demands, claims or causes of action, whether now known or unknown, for trademark or any similar matter, or based upon or relating to the use and exploitation of the images of the Property.

Copyright in the photographs does not belong to undersigned or any other person photographed or, if the photographs were commissioned by undersigned, such copyright is hereby assigned to the Photographer. Executed as of the date first written above.

Individual Owners Corporate Ownership

Owners Name (Please Print) Employees Name (Please Print)

Owners Signature Employees Signature

Date Phone Number Position/Title

Name of Corporation

(Print Name) Address and Phone Number

Appendix H to Business Plan
Personnel Resources- Resumes/Comp

This section is for you to maintain your professional resume, credentials and any prestigious awards that you may have received. You may want to maintain a file of resumes on yourself, your associates and others who will be working with you. Don't forget to include letters of appreciation or testimonials from happy clients.

On your resume be sure to indicate any professional organizations that you belong to, any special courses or training that you have had. Remember, that credential means a lot inside the modeling community, but when you are talking to a small business owner, it may be just another string of letters. So spell it out for him so that he understands what your credentials are.

This is a good place to place your credentials, along with any prestigious awards that you may have received.

Appendix I to Business Plan
Ideas for Themed Shoots/Locations
POTENTIAL THEMES FOR A PHOTO SHOOT

ICE Queen Winter themed shoot with a royalty based theme

Office setting shoot (secretaries)

Glamour Shoot

Boat shoot on Puget Sound with Seattle Skyline in back ground

Port Townsend/Fort Worden shoot (Setting for movie Officer and a Gentleman)

Haunted House Shoot (Georgetown Morgue Kube haunted house)

Museum of Flight?

Adult Only shoot (Center for Positive Sex Therapy)

Hopon/Hop off Glamour shoot around Seattle – Gum wall, Pike Market flowers, Troll

Woodland Park Zoo

Steam Train ride in Chehalis WA or Garibaldi OR or Mt Ranier Scenic Railroad

Steam punk shoot

Fairy Tale Shoot/ Valentines Day Shoot

LOCATIONS
(This is the place to record your favorite locations to shoot in)

- **Spooked in Seattle** 102 Cherry Street, Seattle, WA
 This 'beneath the streets' museum has all sorts of spooky entrapments such as coffins and embalming stations that make for an enticing background.

- **Renton Grotto water System** 1200 Monster Road Southwest, Renton, WA
 This jewel has a very detailed stone and marble mosaic grotto that is part of the Waterworks Park. There is also a monolith arrangement. Parking is limited

- **Seattle Gasworks Park** 2101 N Northlake Way, 98103 Gas Works Park has a play area with a large play barn, and big hill popular for flying kites. Special park features include a sundial, and a beautiful view of Seattle. It has public restrooms.

-
- **Renton Southgate Office Park** 2001 and 2201 Lind Ave SW, Renton, WA
 A replica of Stonehenge sits in the park not far from the Wizards of the Coast headquarters.

- **Preston Mills Park** Preston Fall City Road SE and SE 86th, Preston, WA 98027

Appendix J
How to set up your own Trade-For Shoot
Photo Shoot Rules Of Engagement

Welcome to our Photo Shoot! This themed event is what is known as a 'TF Photo Shoot'. This means that the photographers get to shoot the models in 'Trade For' images for their portfolio. The objective is for models to build up their current portfolio with professional images and for the photographers to get some experience working with different models and build up their portfolio as well. The fees paid for this event cover the facility rental, lunch table and 'behind the scenes' fees so that the artists can concentrate on doing what they do best. Make up artisans work for tips from the models, who tip based on the difficulty and quality of the work, but usually starting at $10. A make-up kit fee is generally provided from the overhead fees.

Administration
Everyone must register and sign the liability release form for the facility. Models sign the model release form and photographers must sign the photographers release form. The host of the event will collect the forms and scan them into a pdf file which will be provided to every photographer. Individual release forms are not allowed.

General Layout

Once you pass the registration table you will find that there is a make-up area where the make-up artists have their tables, chairs and equipment set up. There is also a model preparation area designated for models to do final look type arrangements. And then there is the lobby/waiting area.

Once models are prepared to be photographers they should use the clap board or clipboard to boldly write their name and the name of the make-up artist. Hold that beneath your face and have the host take your profile head shot. This way everyone will know who you are and who did the makeup.

Then proceed to the waiting area. This is the area where photographers and models meet to prepare for their shoot. If you are a model and don't have a scheduled shoot you should be in this area so that the photographers know that you are available. Photographers should frequent this area to see who has become available for modeling.

This is not the time to be shy. Some opening ice breakers are:
 "I'm looking for a photographer"
 "I'm looking for a model"
 "Are you available to shoot?'
 "Who is ready to shoot?"

HINTS
- Break the ice... this isn't a date, its business.
- Photographers' job is to make the model loo great!
- Make-up Artists job is to make the model look great!
- It's the models job to respond to the photographer and work with him/her to create a great image!
- Photographers- No means no…. don't push the models.
- Gaffers tape is your best friend! It's like duct tape, but leaves no residue, doesn't stick to skin and cables and equipment too much.

Suggested Time Schedule

8:00	Support team arrives on location and sets up tables and chairs and registration table. (Don't forget the pens and clipboards)
8:30	Make-up artists arrive and set up their tables and chairs
8:45	Models arrive and sign in, meet with make-up artists Models write their name and that of the make-up artist on clapboard and pose with it.
9:30	Photographing begins
11:30	Break for lunch Try to get everyone together as a networking event. Name tags would help stimulate conversation
12:30	Shooting starts up again.
4:30	End of shooting (Begin to tear down sets and clean up)
5:00	Remove trash and leave the location

Photo Shoot Model Menu

Item	Amount	Costco Cost
Snacks		
Pretzels (bite size)		
Green Grapes	1 clam shell container 4 lb.	8.99
Red Globe Grapes	1 clam shell container 4 lb.	7.99
Cheddar Cheese (to cube)	1 pound	8.29
Muenster Cheese (to cube)	1 pound	
Vegetables (cut for dipping)	Ranch Dressing	
Cherry Tomatoes	2 pounds	5.99
Carrots		
Celery		

Entrée

Rollup sandwiches- flour tortilla shells, ham, cheese, lettuce, Sandwich fixings: bread rolls, ham, turkey, sliced cheese

Item	Amount	Costco Cost
Tillamook Med Cheddar slices	1 pound	9.79
Tillamook Swiss slices	1 pound	8.99
Kirkland Sliced ham	1 pound	9.99
Mini Spiriella meet n cheese	1 package	13.79
Deli Turkey rolls and Swiss cheese	38 count	29.99
Dinner rolls	3 dozen	4.49
Flour Tortilla (to make roll ups)	20 count	5.49

Condiments: Mustard, Ranch Dressing

Beverages
Coffee, cream, sugar, sweetener
Tea- Hot water and tea bags
Bottled water

Utensils
Disposable cups and glasses
Disposable plates and bowls
Disposable flatware
Toothpicks/ Coffee Stirrers/Serving dishes

Checklist for success

I hope that by now you've had a chance to sit down and read over this book. It started out as a guide for new models. Just a few pages. Then models asked for more information which I added. The information sheet turned into a pamphlet. Then into a manual. Then into a book.

Books are fine. But models really want someone to hold their hand and get acquainted with the process. So I assembled some thoughts on this. I'm assuming that the reader is a new model. Or a model who has been dabbling in the industry but wants to get herself organized to get the best return for her minimal investment. So I'm back at the information sheet stage.

Consider this a quick start guide. Make a copy of it and follow it step by step. Let me know how it works!

Checklist for success

- Take a long look at yourself. Determine your strengths, assets and weaknesses. Consider beauty, body and attitude. You can change any of them!
- Find out where the next TF shoots are. Get online at Facebook or model mayhem and find out where the TF shoots are in your area. Jot them down on the calendar.
- Contact the promoter of the shoot and ask to attend.
- If you are nervous, ask a friend to go with you…
- Put together a small models kit. Toss some make-up and a few wardrobe changes into a bag.
- Get to the event a few minutes early. This gives you a chance to scope out the area and become familiar with the environment. Introduce yourself. Remember that people at these events often don't know each other. Or their role. "Hi, I'm Amy, a model."
- Check out and sign the model release. Keep a copy for yourself. You can always take a photo of it with your phone.
- Grab a photographer and make some great images.
- Give the photographer a few days after the event to clean up some of the images. Don't rush them, but keep in touch. "I had a great time shooting with you last weekend. How are the images turning out?" is a great way to prod the photographer.

- When you get the images, put a hard copy in your portfolio. Post the best ones on Facebook or model mayhem or whatever social media you use. Be sure to credit the photographer and make-up artists.
- Keep up with social media. Let everyone know that you are modeling and looking for more gigs. At the shoot, check in with social media. After the shoot, post some images with comments like 'I had a great time shooting with xxx. I hope we get to shoot again soon!'

www.ingramcontent.com/pod-product-compliance
Lightning Source LLC
Chambersburg PA
CBHW072217170526
45158CB00002BA/639